BLACK AMERICA SERIES

AFRICAN-AMERICAN EDUCATION IN

DEKALB
COUNTY

FROM THE COLLECTION OF NARVIE J. HARRIS

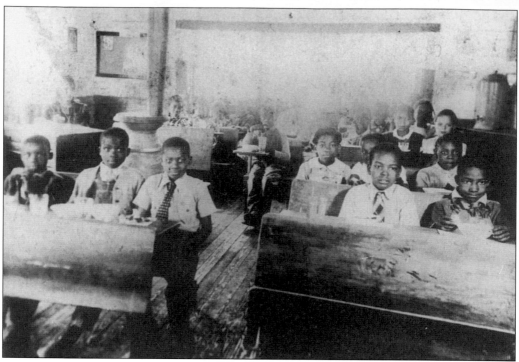

REDAN ELEMENTARY (ONE-TEACHER SCHOOL) HOUSED IN A LODGE HALL. Note the pot-belly stove in rear left.

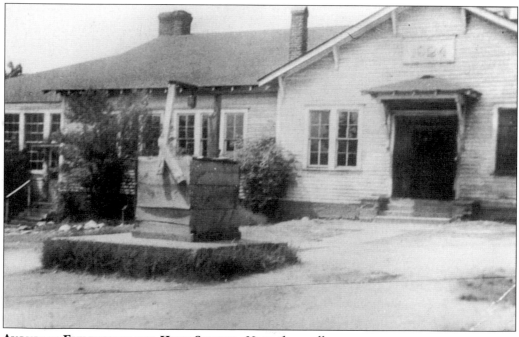

AVONDALE ELEMENTARY AND HIGH SCHOOL. Note the well.

BLACK AMERICA SERIES

AFRICAN-AMERICAN EDUCATION IN
DEKALB
COUNTY

FROM THE COLLECTION OF NARVIE J. HARRIS

Narvie J. Harris, M.eD. and Dee M. Taylor, Ed.D.

ARCADIA

Published by Arcadia Publishing
Charleston SC, Chicago IL, Portsmouth NH, San Francisco CA

Printed in Great Britain.

Library of Congress Catalog Card Number: 99065661.

For all general information contact Arcadia Publishing at:
Telephone 843-853-2070
Fax 843-853-0044
E-mail: sales@arcadiapublishing.com

For customer service and orders:
Toll-Free 1-888-313-2665

Visit us on the internet at http://www.arcadiapublishing.com

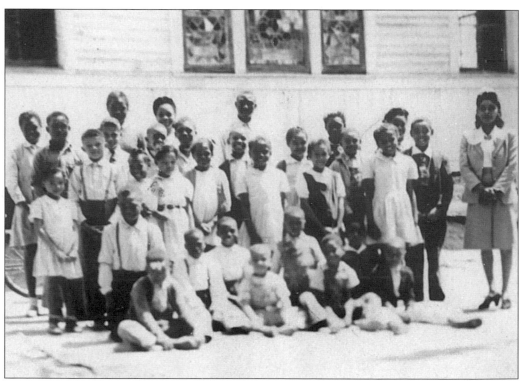

FLAT ROCK SCHOOL HOUSED IN A CHURCH. This was a one-teacher school with Mrs. Frankie Hardy as the teacher.

CONTENTS

ACKNOWLEDGMENTS

To . . .

God, who is the glory and the head of my life.

My parents, James and Anna Jordan, who gave me life, nurtured and taught me Christian morals and values, by precept and example, as well as to my brothers, sisters, and "neighborhood parents" who helped me to become all that I can be.

My sainted husband for 42 years who was my friend and supporter.

Our daughter, Daryll, who brought us joy and happiness. Her marriage to Mike and the birth of Michael, their son, have truly blessed our wider families.

My ministers and Sunday school teachers who instilled in me fervor for living by biblical principles.

The teachers who encouraged and taught me the value of education for life.

The school systems that provided me opportunities to serve boys, girls, and adults. Teaching has always been my desire for a career. Special gratitude to DeKalb County School System where I served four decades.

The DeKalb County Board of Education, who recognized me twice since my retirement by bestowing on me the title of Honorary Associate Superintendent (1985) and by voting unanimously (1998) to name a new school The Narvie J. Harris Traditional Theme School. And to Superintendent James R. Hallford, Board Members Phil McGregor and Mrs. Frances Edwards, the committee, and the community who made the nomination to the Board of Education to name the school in my honor.

Dr. Fannie Tartt, my mentee, who continues to endorse and implement my philosophy and teachings for excellence in education, especially as related to The Narvie J. Harris Traditional Theme School.

Dr. Sid Horne, who initiated the idea to write my educational experiences and who penned much of the historic data related to many of the tasks performed by me as a DeKalb County educator.

Dr. Catherine Turk, who was the first African-American secondary instructional coordinator, for her time and expertise as our editor.

Dr. Dee Taylor, an enthusiastic, professional educator who exhibited her personal interest to see that the story was written and published, and to whom I owe a debt of gratitude beyond comparison for her diligence, perseverance, and creative writing ideas, and co-authorship.

INTRODUCTION

Narvie Jordan Harris has seen many changes in DeKalb County over the past 40 years that might be difficult for today's generations to fathom. As one of DeKalb County's first six Jeanes Supervisors, Mrs. Harris has stories to tell about DeKalb County's school history which are both of interest and of great value.

It was as if there was an iron curtain between the two races in the school system—a black and white. However, Mrs. Harris is proud of what she, the principals, teachers, and communities were able to accomplish. This book shares a glimpse of education in DeKalb County during a challenging period of history. Chronicled in her personal pictorial gallery and brief verbal accounts are rare moments depicted in a time when educational equity was merely an evolving concept in search of fulfillment of the promises to all citizens.

Learn the invaluable lessons from Narvie Harris's childhood to adulthood and values she gained and shared with so many during her journey to educational excellence. Travel the roads of the infamous Jeanes Supervisors, who influenced—beyond measure—teaching, learning, and respect for educators in DeKalb County. Join her search for the hope of educational equity and justice during the years that presented challenges that defy words. Share the thrills of victory as many successes were actualized because of prayer, hard work, vision, commitment, perseverance, and a genuine love for boys and girls—and their DeKalb villages. Capture this era, the triumphs and the personal pearls of wisdom for a 40-year period never to be forgotten. Enjoy Mrs. Harris's personalized lessons and quotations that many recall and use today.

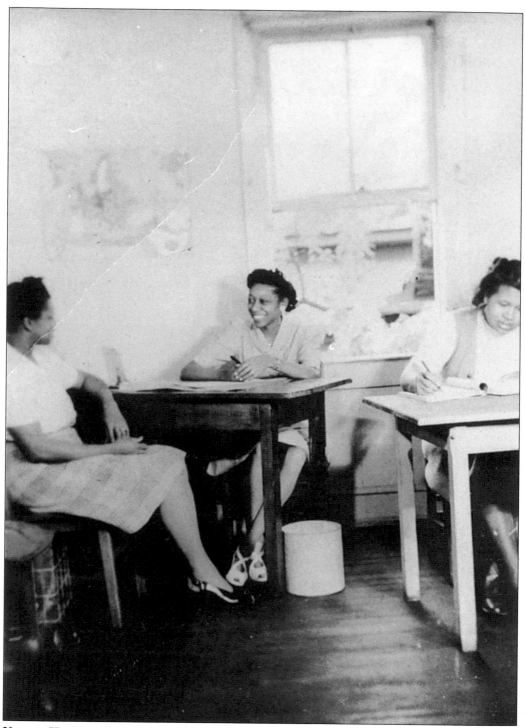

NARVIE HARRIS IN HER FIRST YEAR IN DEKALB (1944–45) IN THE JEANES SUPERVISOR'S OFFICE AT COX FUNERAL HOME, LOCATED ON MARSHALL STREET, DECATUR, GEORGIA. The teachers pictured here from left to right are Isoline Sherard, Narvie Jordan, and Marion Wells.

One

A PACESETTER FOR LEARNING

THE LIFE AND TIMES OF NARVIE HARRIS

Learning was planted like a seed in us as children in our home. It germinated. Learning bloomed from the immense joy of it, which was planted deeply inside me. I gathered my learning into a lifetime bouquet and then shared its beauty and fragrance generously with others as I traveled unknown roads. Learning begins at home, learning must be enjoyed, and it must be shared with others. I took these lessons into life's many gardens, and they served me—and so many others beyond measure.

I remember vividly . . . Our Sunday afternoons were spent reading, playing the piano, and my father playing the trumpet. I can vividly see the sites even now from our automobile rides either to Asa Candler Airfield to see planes land and take off on red, muddy runways—or a ride to Stone Mountain. Other times, my mother would take us—all of her children—to ride on the trolley car to the Decatur Courthouse for 5¢, turn the seats forward and return to Atlanta. It was not a custom for Blacks to be seen in the streets of Decatur; therefore, we stayed on the trolley. During weekdays we would enjoy movies and afterwards an ice cream cone. Some evenings my father drove us to the Farmer's Market where he purchased fruits and vegetables for my mother to can and preserve. We remember how my mother tired of us overloading the automobile with neighbors' children. We wanted to share the joy with everyone. This intrinsic feeling of shared learning carried into my actions as a teacher for years.

FAMILY

James and Anna Jordan, my parents, created a wonderful family life for my most cherished family members; my brother James was their first child, and I was their second, and Harvey was the third born in Johnson County, Wrightsville, Georgia. The other children, Edward, Anna Pearl, Robert, and Juanita, all were born in Atlanta, Georgia. In Wrightsville, my father owned and operated a pressing club and tailor shop. He continued this business on Auburn Avenue when the family relocated to Atlanta, Georgia.

NARVIE'S MOTHER, ANNA HOBBS
JORDAN.

NARVIE'S FATHER, JAMES EDWARD
JORDAN. .

10

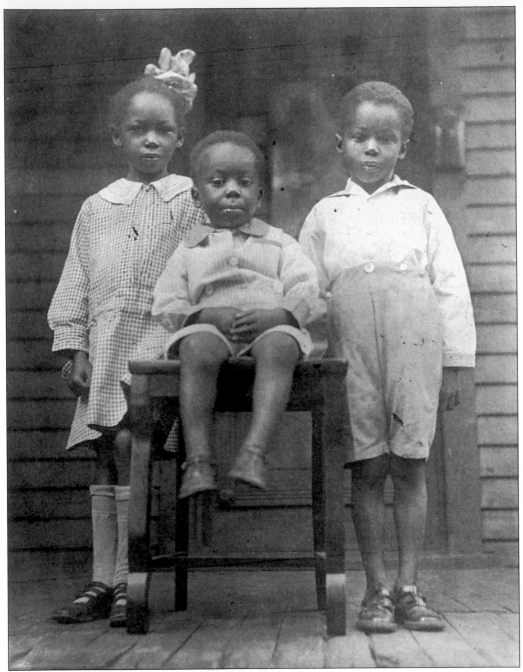

NARVIE AND HER SIBLINGS EDWARD AND HARVEY (LEFT TO RIGHT). They are pictured here looking their best for this cherished family photograph. We were good children, a priority and expectation of our parents.

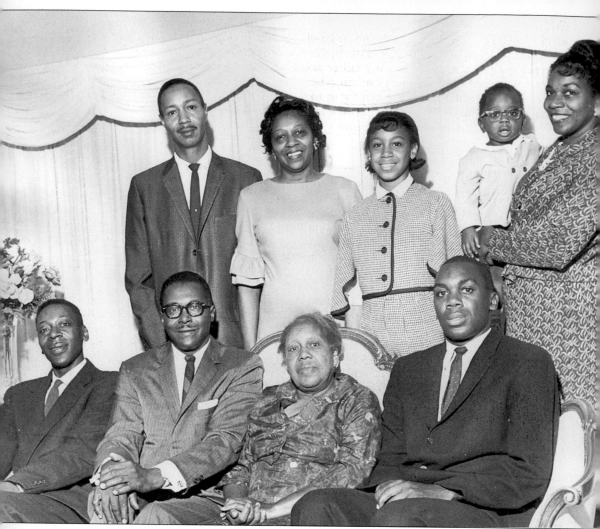

THE JORDAN FAMILY. Pictured from left to right are (front row) brothers Edward and Harvey, mother Anna, and brother Robert; (back row) husband Joseph Harris, Narvie, daughter Daryll, and sister Anna Pearl Scott holding her son Miguel.

RELIGION

Religion played an important role in our family life. My parents moved their memberships to Atlanta and joined Mount Olive Baptist Church where the pastor was Rev. James Nabrit Sr. They sang in the choir and my father accompanied the choir with his trumpet. The children attended Liberty Baptist Church, where Rev. Ernest Hall was the pastor. We lived in close proximity, which made it easier for us to go unaccompanied to Sunday school, Baptist Youth Training Union (BYTU), and church services.

Two things I always knew in our house were we were going to school, and we were going to church.

FAMILY AND THE ARTS

As for what I thought was mere fun and recreation, my sisters, brothers, and I participated in the usual activities for children during my developmental years. My parents insisted we all learn to play the piano, which, for me, began at age five with Miss Florence Morrison, a student at Spelman College who was my first music teacher. *Wheat Street Baptist and its music has continued to nurture me spiritually throughout my life.* My father was also a member of the Elk's Lodge Marching Band, and my mother enjoyed playing the piano.

ELEMENTARY AND JUNIOR HIGH YEARS

I remember beginning school; it feels as if it were just yesterday. I was five years of age when my formal education began at Yonge Street School where Miss C.B. Finley was principal and Miss Rebecca Dickerson was my first grade teacher. In the mid-1930s, we moved to northwest Atlanta, 979 Lena Street, where I was enrolled in the sixth grade at Ashby Street School and Miss A.D. Badger was my teacher. I remember her because of a gift at Christmas that she gave all of her students—a chocolate popsicle. This was a first for me—receiving a gift from a teacher. For my seventh year in school, I entered Booker T. Washington High School. Miss Venitia Nichols was my homeroom teacher and also taught me English; I was placed in the accelerated group. Students were promoted three times a year instead of twice a year. *It was during the seventh grade when I realized that students placed in the accelerated class were academic achievers.*

The Lesson: It is the positive, formative confirmations that must be given to children for them to gain their momentum for life.

HIGH SCHOOL YEARS

Mr. C.L. Harper was the first principal of Booker T. Washington High School, the first high school built and occupied by blacks in Atlanta in 1924. He was small in stature, but he was a giant leader whose vision and actions led the staff and students, including me, to great educational pursuits.

CHARLES LINCOLN, THE FIRST PRINCIPAL OF THE BOOKER T. WASHINGTON HIGH SCHOOL, 1924. Narvie Jordan graduated in the class of 1934 (the 10th class).

13

I remember having dedicated teachers who taught both book knowledge as well as morals and values. They were dedicated, mature, caring, sharing individuals; most of all they were master teachers. They inspired each child to become somebody. In June 1934, we graduated from high school with over 365 students—the largest class in the ten-year period of Booker T. Washington High School's existence. In June 1984 we celebrated our 50th Class Reunion. The class of '34 continues to meet and to award book scholarships to seniors in the school.

In the fall of 1934, I entered Clark College. I was awarded a scholarship to enter Tuskegee Institute in Alabama, but because I had never been away from home, I did not choose to leave my family.

Early Work Experience: Applied, Real-life, Mentored Learning

During my high school and college years, I worked every Saturday as a clerk in my father's business on Auburn Avenue, N.E. He was the first and only black (at that time) to own a department store with clothing for men and women, tailoring and dry cleaning in Atlanta. There has not been another store like his since he sold the business. Many of the activities that the other children participated in on Saturday escaped my experiences and found me at work. When business was lean, I worked daily during the summer. My father was a born leader in the business world. His background was an example to us children—mentoring of the best kind. In 1918 he graduated from Mitchell Tailoring School in New York City. He also studied other courses by correspondence, reading and traveling. In addition, he manufactured and sold cosmetics. As a licensed cinema photographer, he made photographs and movies of the World's Baptist Alliance in London, England, in 1955. He owned and rented properties in Atlanta and New York. In other words, he was an entrepreneur blessed with a creative mind; he pulled himself up by his own bootstraps.

Wanting to be a Teacher

I cannot remember when I didn't want to become a teacher. As a child, when we played school, I was nearly always the teacher. I emulated all the "good" teachers I was blessed to have in school. I talked like them; I helped children in the same manner that I witnessed; I reprimanded firmly but with love—just like my teachers. I always felt that I had a special gift to work with others. Education helped me to unfold that gift. I learned that it was a gift that was meant to be shared with others. The more I shared, the more refined the gift became. What a simple yet profound lesson.

The Lesson: The more you genuinely give, the more you genuinely receive.

Expectations

Among the values taught us at home was to get an education, strive to be the best, and attend church. There was never any doubt among my siblings that we were going to school each day and to church on Sunday. It was expected of me to succeed because I was the oldest of five children; my father and mother expected me to set the example for the other children who were younger than I.

The Lesson: Expectations of children must be set and set high—and clearly understood by all parties involved that what is expected WILL be accomplished.

My First Job Teaching and Life's First Real Adult Lessons

I graduated from college and fulfilled my dream of becoming a teacher in 1939 in Decatur County, Bainbridge, Georgia. I taught in a Rosenwald building at Fowlstown where my principal was Mr. Squire Bryant and my Jeanes Supervisor was Miss Lillian E. Williams. I taught grades three and four and home economics to rural children. I remained there for two years, and I taught adults homemaking skills on a limited basis in the evenings.

NARVIE JORDAN, COLLEGE GRADUATE FROM CLARK UNIVERSITY, 1939. I prided myself on being a serious scholar during the years spent at Clark University where I graduated in 1939. I then spent 1943–44 at Atlanta University as a member of the first group of teachers chosen to study supervision through a grant from the Georgia State Department of Education. Upon receiving a Masters Degree in Education and Administration, I was employed as Jeanes Supervisor for 17 schools, grades 1–12 for 20 years.

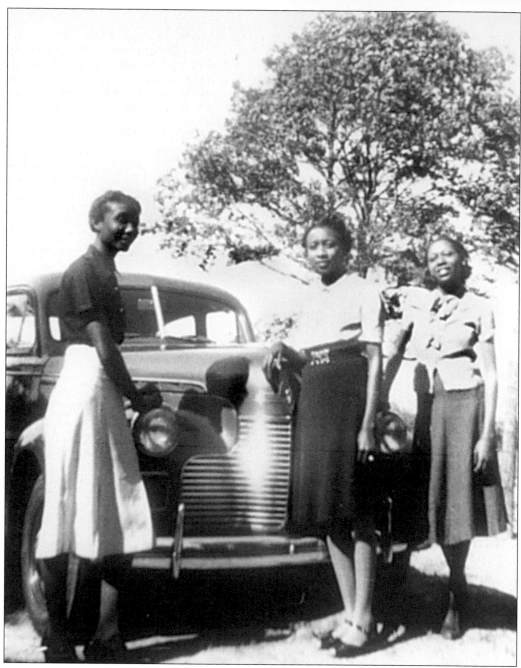

FIRST YEAR TEACHING, 1939, ELSIE AND RUTH GAINES, NARVIE (LEFT TO RIGHT). In 1941, I taught one year in Henry County at Locust Grove, Georgia, where Mr. J.C. Collins was the principal. I taught sixth grade and home economics, which was my major in college. Among my duties was to prepare lunches with government-issued foods such as apples, yellow grits, meal, fat back, pork and beans, honey, and other miscellaneous food stuffs. I also served as the music teacher and taught adult classes in the evenings. Because of the racial challenges, I resigned from Locust Grove and took a position in the Calhoun County schools (1942–43).

A New Kind of Abolitionist

There existed in Georgia until 1954 a dual system of education for blacks and whites. I met Mr. R.L. Cousins, who was a white gentleman, at the Georgia State Department of Education. In 1939, when I graduated from college, he served as State Director of Negro Education. He was a sincere, honest, dedicated leader who was aware of the educational needs of black teachers, administrators, and children; he worked assiduously to eradicate the evils of segregation in education. He was responsible for assisting me in securing each position I held from my first to my last in DeKalb County. I will forever be endeared to him for the confidence he had in me. In the summer of 1942 when I resigned from Henry County, I went to Mr. Cousins and explained why I resigned. He understood and had me contact the principal in Calhoun County, Edison, Georgia. Mr. James Slaton, principal, came to Atlanta to interview me. He accepted me for the position of home economics teacher in a senior high school. There I taught grades 8–11 and also taught adults in an evening program.

Mr. Cousins visited the school where I was teaching in Edison in the spring of 1943. He was impressed with my work and offered me a scholarship to Grambling College in Grambling, Louisiana. He also offered a scholarship to the principal and the Jeanes Supervisor, Mrs. Marie Pullens. The Calhoun County Board of Education paid for the mileage of the supervisor's car; Grambling's scholarship took care of our room, board, and tuition. The workshop was in the area of elementary education, my first formal elementary training. It was the beginning of a new vista in education for me.

The Lesson: Everyone who can help you does not necessarily look like you. Good people can come in all colors, shapes, and sizes. Move beyond the cover and assess the deeds.

THE NEW KIND OF ABOLITIONIST GIVING FREEDOM IN A NEW WAY. R.L. Cousins, State Director of the Division of Negro Education, is pictured here with Narvie J. Harris, Atlanta University.

COMING TO DEKALB

I came to DeKalb County August 15, 1944, eager to begin my new duties as Jeanes Supervisor after receiving a Master's Degree from Atlanta University. As a young, single, and enthusiastic professional, I walked into my office located in the Cox Funeral Home in Decatur, Georgia, fully prepared to assume the myriad of responsibilities that would earn me the title of black superintendent. Although the title was an unofficial one, I would, in fact, play that role for hundreds of people in the years ahead.

Although I was considered quite young for such a responsible position, I possessed an air of authority born in the conviction that important work was too long left undone, and there was no time to waste. I was confident as I left my office and walked two blocks to the corner of Atlanta Avenue and McDonough Boulevard, where I officially met for the first time with William Rainey, superintendent of DeKalb County Schools. That muggy August morning began my tenure under five superintendents over the next four decades. The Jeanes title, named for a Quaker philanthropist Anna T. Jeanes, who contributed funds to upgrade schools for blacks in the south, charged me with total responsibility for the operation of the 17 schools for Blacks in the county.

NARVIE HARRIS'S FIRST YEAR IN DEKALB COUNTY (1944–45). We gathered ourselves and our visions in the Jeanes Supervisors' office, then located at the Cox Funeral Home, Marshall Street in Decatur, Georgia.

OUR FAMILY: JOSEPH, NARVIE, AND DARYLL. Although I was very busy with my new position, I found time for a social life which eventually led to a long and beautiful marriage of 42 years to Joseph L. Harris (November 19, 1945). The affectionate name that students used to call me, "Miss Narvie," was now officially "Mrs. Narvie J. Harris."

DARYLL HARRIS GRIFFIN, HUSBAND MIKE GRIFFIN, AND SON MICHAEL. To our union, we were blessed with one daughter, Daryll. No mother could have been prouder of her child's many virtues and accomplishments over the years. Daryll married Michael Griffin, and our united families have been blessed with the joys that only a grandson can bring, Michael.

THE IDEA TO BECOME A SUPERVISOR

When my grades arrived from Grambling, I went to Mr. Cousins's office to say, "Thanks." I also wanted to show him my grades, which were all As. He was highly complimentary and wished me continued success. He then questioned me asking, "Do you want to be a supervisor?"

I told him, "I've never given it a thought." He explained to me that the Georgia State Department of Education and the Southern Education Foundation were searching for outstanding teachers to enroll in a year's program in Administration and Supervision. One program would be at the University of Georgia in Athens and the other at Atlanta University in Atlanta—still a dual system based on race. He urged me to go to Atlanta University and to tell Mr. J.P. Whittaker, registrar, that he sent me to get an application. He cautioned me that 19 applicants were ahead of me. Later six blacks attended Atlanta University, and nine whites attended the University of Georgia. In the Administration and Supervision program I received a Masters of Education in 1944 and continued to pursue higher learning and advanced certifications from various institutions throughout the years. The training consisted of formal book learning and visiting school districts in Georgia and out of the state to observe promising programs in public and private schools, both elementary and high schools. The 30-hour course work in Administration and Supervision at Atlanta University included experienced Jeanes Supervisors visiting our classes and sharing their on-the-job experiences. Members of the classes were required to do a nine-week internship. I was assigned to DeKalb Schools to work with Mrs. Mattie B. Braxton, Jeanes Supervisor. There were periods I observed her in all phases of work in grades 1–11. She gave me an opportunity to observe, plan, and carry out small study group meetings. There were 17 run-down school buildings for blacks: 12 in churches, 2 in lodge halls, and the other school buildings in poor environments. Later I was given full reins to work with teachers in numerous educational experiences.

The world was at war in 1944. Most able-bodied men were away in the military service, leaving women and children, and the elderly to carry on at home. As the Jeanes Supervisor, I found school children collecting scrap iron, which would be used to build airplanes, bombs, rifles, and bullets. They bought war bonds and victory stamps; they prayed for their fathers, their older brothers, and men away in the war. They went to the "cool refrigerated Decatur Theatre" to see Gary Cooper and George Raft in *Souls at Sea* and other war movies. They looked longingly at pictures of the Western Flyer bicycle advertised in the *DeKalb New Era* newspaper for $28 at Western Auto. Sinatra crooned; scientists worked secretly on a bomb to end the war. Roosevelt brought fame to Warm Springs, Georgia, as he showed signs of ill health. It was in this setting that I found fertile ground for my work as a Jeanes Supervisor.

THE NEEDS SURVEY FOR THE PLAN OF ACTION

When I began my duties as Jeanes Supervisor, there were 17 schools, 1,500 students, and 36 teachers. Twelve schools were housed in large halls and churches with the exception of Mount Moriah School (used as a demonstration school by Atlanta University). I had some knowledge of the needs for the teachers, but I still contacted Mr. Cousins and the supervisor of student teachers in the Atlanta colleges. The teachers' greatest problem was transportation to the DeKalb schools from Atlanta, complicated by the low teacher salary making it difficult to afford meager means of transportation to their jobs. However, through much effort, I was able to fill all the vacancies by school opening. Teacher certification included certified teachers with bachelor degrees or those with a County License (provisional certification pending more course work).

Mr. Coy Flagg was the new principal in Lithonia in 1944. He was the only principal with a Masters Degree. It was a combination school, housed in a rock structure. Blacks worked in the Charlie Davidson quarry with little or no provisions for good health practices; they were exposed to the dust at the quarry; as a result, many were victims of tuberculosis in Lithonia and Redan areas. This concerned me as did the lack or absence of so many minimal needs to help educate the black population.

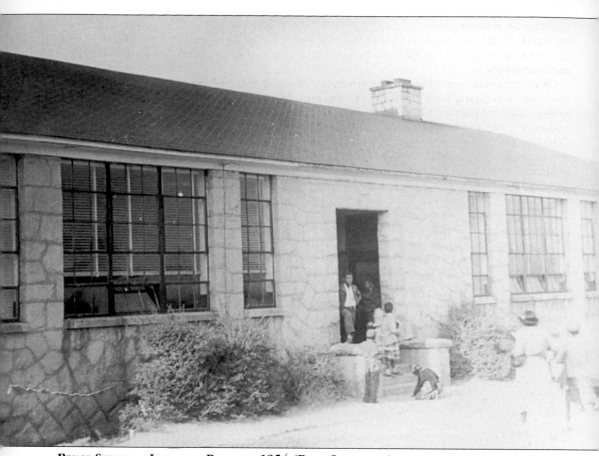

BRUCE STREET IN LITHONIA, PRIOR TO 1954 (ROCK STRUCTURE).

Inadequate water was also a problem. Only Mount Moriah, a one-teacher school located off North Druid Hills Road (in close proximity of the current Open Campus High School), had running water; all schools for Blacks had inadequate water-related facilities, including outdoor toilets.

Other concerns were the poor health habits of adults and children, lack of facilities in the communities, absence of community organizations (except the church with itinerant), under-educated pastors, the absence of sewers, street lights, and poor-to-no jobs other than domestic work for women. Men from the Scottdale area worked at the Scottdale Cotton Mill. There were few to no black doctors who could provide basic medical care. We learned there were only two doctors who would provide medical attention to blacks: Dr. R.S. Douthard Sr. (black) in Decatur and Dr. Conrad Allgood (a white doctor in Scottdale who had separate days for coloreds and whites to visit his office for medical attention). His son, Mr. Conrad Allgood, was later principal at Tucker Elementary where I served as his supervisor. The lack of preventive health knowledge indicated a definite need to develop a health program and curriculum—which I did.

With the new curricula came the need to secure new books. The practice of the day was that old books, unfit for use, were handed down to blacks from the white schools. This practice also existed in Atlanta Public Schools where I attended. Books and materials were issued to blacks without removing the name of the school. So children were always aware of the message sent to them saying that they were second best. Comfortable chairs, desks, and facilities were out of the question.

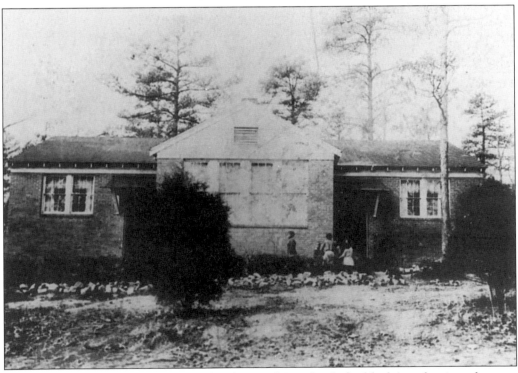

MOUNT MORIAH. This was the only school (out of 17 schools for blacks) at the time that was actually built to be a school. It once served as a demonstration school for teachers at the Atlanta University Center.

ORGANIZING THE HEALTH COUNCIL

A group of educators and community workers began plans for an organized health council at Avondale Colored Elementary and High School, with Mr. William Hatton, principal, and with Mr. Everett. We did a survey of the community and listed health problems. All agreed that running water should be our first priority.

We contacted the director of DeKalb Water Department inquiring about what we needed to do. After a long period of time, he responded that we "had to get money from each family for a meter" extending from North Clarendon and Ponce de Leon to the school on Cedar Street. We succeeded in securing the money, which was quite a job since there were poor whites and poor blacks who sacrificed because everyone wanted running water. We contacted the DeKalb Water Department informing the director that we had the required money for the meters. After securing the money for the meter as directed, the director still rejected our request for water. The council refused to give up.

The Lesson: Effective educators know they must solicit and secure the support of community stakeholders.

We sought help from community agencies, and as a result, we were able to get the water lines installed for running water. This is a success story that was not easy to gain. These efforts brought into focus other problems and also brought the black and white residents together. Each group needed one another because each suffered the same community problems. This clearly demonstrated how the community worked together for the good of all the citizens.

The Lesson: Effective teachers extend their energies outside the classrooms to help solve those basic life challenges that can negatively affect student learning inside the classroom. No water to drink equates to no desire to learn. Maslow's hierarchy of human needs is true for all people.

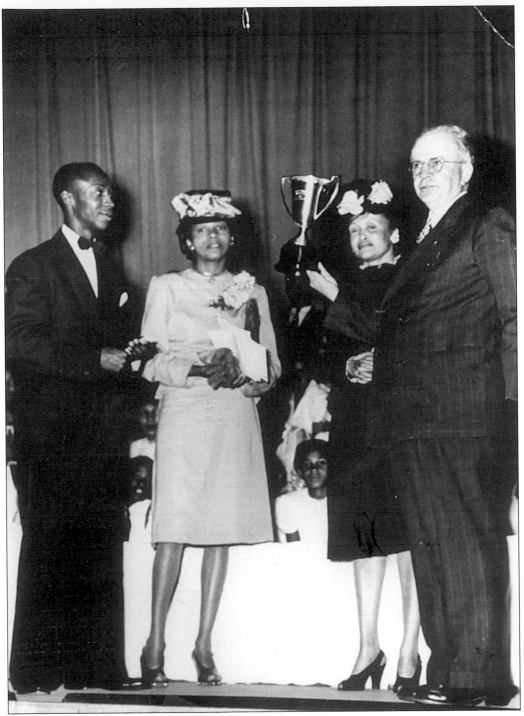

HEALTH COUNCIL AWARDS ASSEMBLY. Pictured here are William Hatton, Narvie Harris, Catherine Ivory (County Health Nurse), and J. Sam Guy (member of DeKalb Board of Education and professor at Emory University).

NEW SCHOOLS

In 1955, the State Department of Education implemented the Minimum Foundation Program in Education (MFPE) and established the School Building Authority. This program was the funding source for the new constructions for Georgia schools for black and white children.

CURRICULUM DEVELOPMENT AND INSTRUCTIONAL STRATEGIES

It is important to note that there was no curricula for teaching black boys and girls. Each month I met with teachers grades 1–11 to develop a solid curriculum and strategies in all subject areas, with special emphasis on the essential skill of reading. I also focused on active teaching strategies. My instructional philosophy was to require teachers to be engaged actively with students.

Lesson: You teach from your feet and not from your seat.

The lack of enrichment subjects (music, art, health, and physical education) was an equal concern along with the need for other academic subjects, for which we developed a curriculum simultaneously. I was able to recruit, secure teachers with minimal and often special skills in the above areas, and then make recommendations to the superintendent. To address the music deficiencies in the curriculum, I bought 25 copies of All Occasion Song books. We issued them to teachers in each of the 17 schools to teach children's songs appropriate for their age level. "Raising of hymns" was the musical practice in the '40s. Children's songs were taught by teachers in all the schools and led the teachers and me to conduct our first Music Festival in 1946.

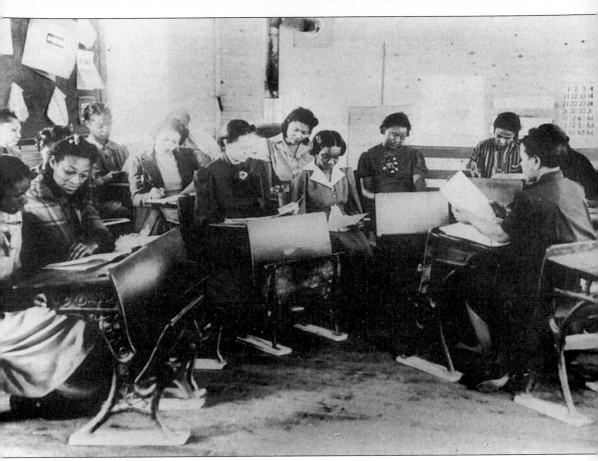

TEACHER INSERVICE TRAINING AND CURRICULUM WRITING.

ELEMENTARY BAND AT STONE MOUNTAIN SCHOOL. Mr. Dawson was both the principal and band instructor. The Rosenwald Building had four classrooms.

ENRICHMENT SUBJECTS

Annually we sponsored the following activities beginning in the 1940s: a county-wide Music Festival, Doll Show, Hobby Show, Science and Social Studies Fairs, Career Clinics Education, and Business Weeks for high school students; students participated in the DeKalb County Extension Service County Fair in Panthersville. All of these activities and more gave enrichment to the impoverished communities where blacks resided. Attendance was usually excellent because it gave the children and their families a place to go and enjoy themselves.

NEW SCHOOLS

In 1955 the State Department of Education implemented the Minimum Foundation Program in Education (MFPE) and established the School Building Authority. This program was the funding source for the new constructions for Georgia schools for black and white children.

Top: **GROUNDBREAKING AT LYNWOOD PARK SCHOOL.** Pictured from left to right are Mr. Harvey Coleman (principal), Mrs. McDaniel (PTA president), Narvie Harris, and Superintendent Jim Cherry.

Center: **BRUCE STREET SCHOOL GROUNDBREAKING.** Pictured here from left to right are Vera O'Neal (business teacher), Narvie Harris, Mrs. Birdsong (PTA president), Mrs. Golden (lunch supervisor), two community ministers, and Coy Flagg (principal).

Bottom: **AVONDALE COLORED ELEMENTARY AND HIGH SCHOOL FACULTY.** Maude Hamilton, principal, for which Hamilton High School was later named, is the seventh person from the left.

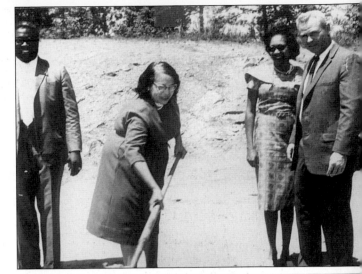

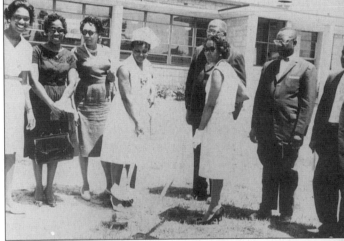

After surveying the county's 17 schools, a committee and I recommended the most feasible consolidation plan: (1) Hamilton, (2) Robert Shaw, (3) Lynwood Park, (4) Bruce Street, (5) County Line, and (6) Victoria Simmons. Hamilton High was named for a former African-American principal, Mrs. Maude Hamilton.

Robert Shaw School was named for an African-American landowner who lived in Scottdale where the school is located. He donated the land. Victoria Simmons was named for a former student of the former Stone Mountain Colored Elementary School. Bruce, County Line, and Lynwood Park were named for the communities. Many roundbreakings began with the dawn of the new day of schooling for the children of DeKalb County.

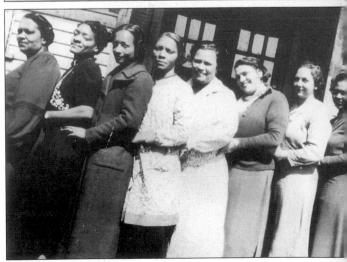

ATLANTA PTA DISTRICT WORKSHOP AT WHEAT STREET BAPTIST CHURCH. Narvie Harris (center front row) was the president in 1959.

BEYOND THE ROLE OF SUPERVISOR

Examples of my additional roles as Jeanes Supervisor included services other than those tasks that focused on the formal classroom situations: served as director of Headstart during the summers; served on the DeKalb and Metropolitan Red Cross Boards of Directors; organized the DeKalb PTA Council for blacks in 1945; served as chaperone (nine years) for students attending the Annual School Safety Patrol trip to Washington, D.C., and New York; coordinated the Summer Extended Enrichment Program, professional staff development; and many other responsibilities.

PTA

All schools for blacks were organized into PTA units. They became active members of the district, state, and national PTA congresses. In 1945 I organized the DeKalb PTA Council.

This effort led to systematizing a program for adult education through the PTA in each unit. The council meetings were held monthly at my office at 315 Marshall Street, Cox Funeral Home, Decatur, Georgia. The first few years were spent teaching unit members parliamentary procedures. Films, skits, role playing, speakers, and general discussions on "how to do it" were used as tools of instruction. Participants became very efficient at their tasks in leadership and fellowship roles. They accepted the knowledge, and today they are competent leaders in their churches and communities.

In 1953–59 I served as president of the Atlanta District PTA. Counties encompassed were Fulton, Atlanta, Decatur, DeKalb, Cobb, and Cherokee. I held two meetings a year. In the fall we conducted a District PTA Workshop, and in February we held our District Meeting, rotating to each county in the district. Each April we attended the Georgia Congress of Colored PTA Convention and in June attended the National Congress of Colored PTA Convention. The National PTA was dissolved in 1970, and the Georgia Congress of Colored PTA was dissolved in 1971 due to desegregation of schools.

Narvie Harris, 1960s. After the closing of the schools for blacks, I became a part of the central office staff. The office was located at the old Scottdale Elementary School, Ponce de Leon Avenue.

Jeanes Supervisor's Role Changes

I became a member of the desegregated DeKalb School System staff in 1969, when I was named Instructional Coordinator for Elementary Education, a title I retained until retirement on June 30, 1983.

During 1969–83 my role changed from that of Jeanes Supervisors in charge of schools for blacks to working with all schools in DeKalb County, regardless of racial makeup of the school population. The transition for me personally went smoothly. However, the transition as a whole was a very complicated change. Each administrator used his or her own discretion at the local school level to receive the small number of black students and staff entering the white schools. Some black teachers transferred to the white settings with the students. This way, the students felt they had "someone" to whom they could seek assistance and advocacy.

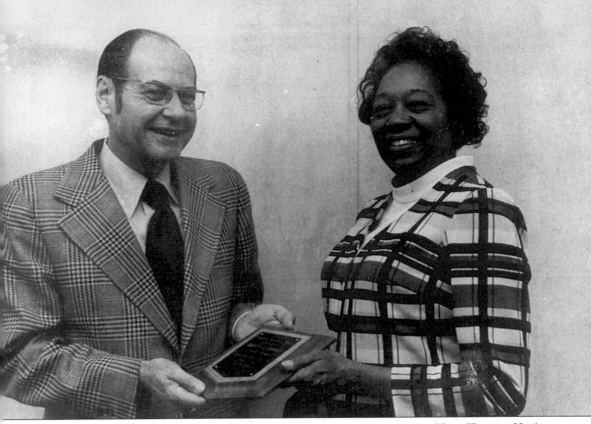

DR. T.W. HOLLINGSWORTH, DIRECTOR OF ELEMENTARY INSTRUCTION, WITH MRS. HARRIS. He is presenting her with the Johnnie V. Cox Award, sponsored by the Georgia Association for Curriculum and Instructional Supervision (GACIS).

Many black students missed activities at their "all black" schools—their football and basketball teams, choruses, bands, cheerleaders, Miss Bruce Street pageants, etc. Eventually, they became a part of these activities in their new schools. Parents, in many instances, said that they did not feel welcomed into the predominantly all-white schools. Parents were concerned about their children's best interests. They were often made to wait for a long period of time to see the administrators. Many felt they were "talked down to" in a demeaning manner—not as an adult. The adjustment to better conditions was not an easy transition but a necessary one.

Superintendent Jim Cherry made it very clear to the county-wide staff of administrators that supervisors were his right arm in the schools. I was accepted in the schools as a supervisor from the central office with all the rights and responsibilities as my co-workers in the same capacity.

My individual leadership style now merged with that of the central office staff; no longer did I plan and execute alone, but I was a part of the total instructional department. This meant quite a change and relief for me. I continued to expand my education. The State School Superintendent Jack P. Nix selected me to join the delegation to study schools in West Africa. Twenty Georgia administrators visited Ghana and Nigeria as part of this exchange program, which was a part of the U.S. Department of Education and Northwestern University.

33

STATE SUPERINTENDENT JACK NIX CONGRATULATES NARVIE HARRIS. Harris was selected to join the Georgia Administrators' West Africa visit in 1972.

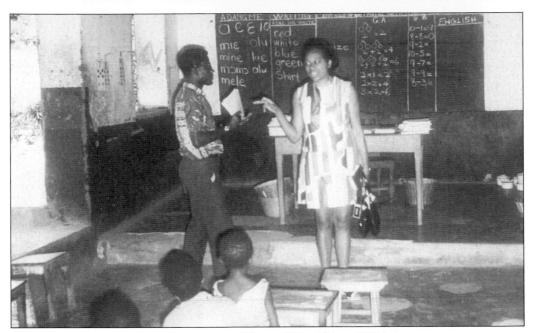

NARVIE WORKS WITH TEACHER AND CLASS. (Ghana, West Africa, 1972.)

WEST AFRICA (GHANA AND NIGERIA) VISITATION BY GEORGIA'S ADMINISTRATORS 1972. Harris is at left in the second row.

MRS. HARRIS WITH STUDENT SHOWING SCIENCE PROJECT. Pictured is Angela Rowland of Wadsworth Elementary School.

HARD WORK IS REWARDED

Even as my professional career began to close, I continued to be a champion for boys and girls. Today I enjoy volunteer working with SACS Committee Review Teams, judging academic festivals, and serving as a guest lecturer for many teachers and students.

HONORED IN 1985 AS THE HONORARY ASSOCIATE SUPERINTENDENT. The presentation was made by board member Donna Wagner.

Two years (1985) after my retirement, the DeKalb Board of Education and Superintendent Robert Freeman formalized the title of Honorary Associate Superintendent and conferred it upon me in recognition of my high level of service in the interest of educating boys and girls in the DeKalb County School System. In November 1998, the board, Superintendent James R. Hallford, and the community bestowed another recognition for the standards of educational excellence that I pioneered by naming the first DeKalb County school for a living African American and female—The Narvie J. Harris Traditional Theme School on McGill Drive in South DeKalb.

I am so very proud of the educators of DeKalb County schools; I am especially grateful to those champions selected to ensure the highest standards of education at the Narvie J. Harris Traditional Theme School. My hope is that these educators will continue to be models of a motto that has guided my work with students and educators, *"You can no more teach what you do not know than you can come back to where you did not go."*

36

Two

TRAVELING THE ROAD OF THE JEANES SUPERVISORS

As Jeanes Supervisors we pledge

The Light of Truth where it may lead
The Light of Freedom revealing new opportunities for service
The Light of Faith opening new visions of the better world to be
The Light of Love daily binding brother to brother
And Man to God in ever closer bonds of friendship and love
We Shall Go Forward in Love

—From The Pledge of Jeanes Supervisors (1923)

JEANES SUPERVISORS IN DEKALB COUNTY NEGRO SCHOOLS

The Jeanes supervisory program was under the Georgia State Department of Education. The Division of Negro Education in the Georgia Department of Education was established in 1911 to help provide more adequate educational opportunities for Negro children in Georgia. Jeanes supervision in DeKalb County Schools is the story of six remarkable ladies who started in 1923 on an educational journey to improve education for both boys and girls and residents in each community. Jeanes Supervisors were black men and women in the South called upon to raise the educational sights for blacks—especially during the days of segregation in the South. In 1912–1913 there were 16 Jeanes Supervisors in 16 Georgia counties.

Anna T. Jeanes was a white philanthropist and humanitarian who donated funds to educate black boys and girls in the South. The monies were later to become known as the Jeanes Fund. In 1908 in Henrico County, Virginia, the first Jeanes Supervisor was discovered by Superintendent Jackson Davis, who was appointed by the State Board of Education. As he visited schools, he observed the "hands on" teaching by Virginia Randolph in a rural county school. He wanted to improve learning by educating the children, thus improving living conditions. She was employed and became the "first" Jeanes Supervisor. She focused her instruction on the 3 Rs as well as real-life skills and experiences.

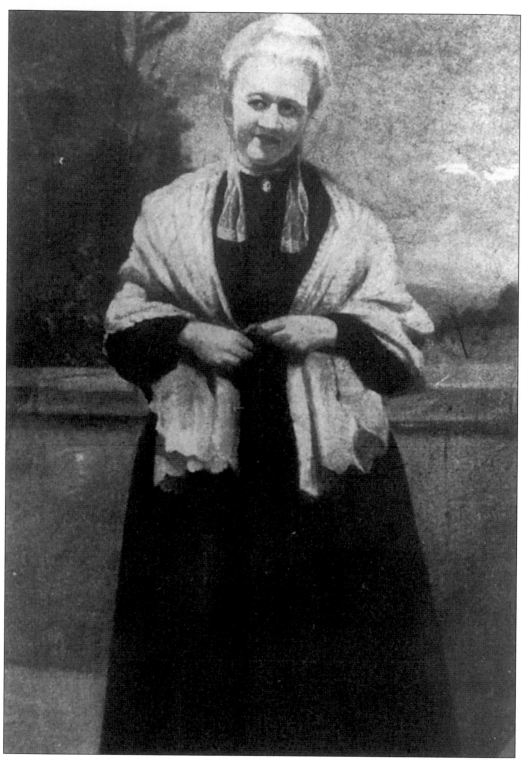

ANNA T. JEANES, PHILANTHROPIST FOR JEANES SUPERVISORS.

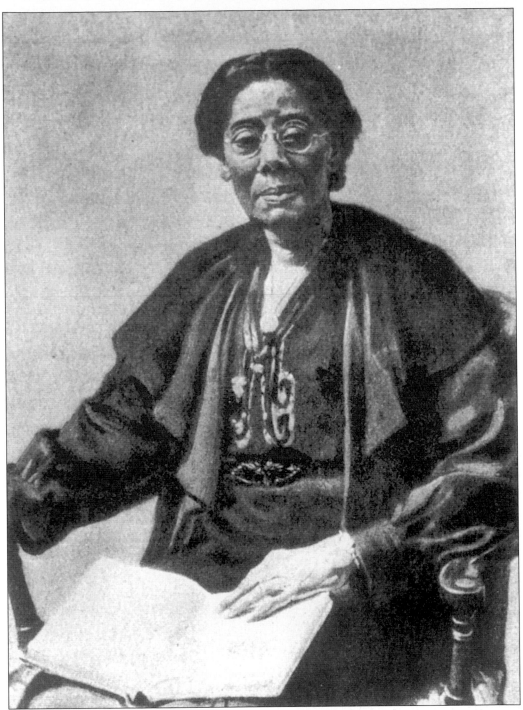

VIRGINIA RANDOLPH, FIRST JEANES SUPERVISOR IN VIRGINIA (1908).

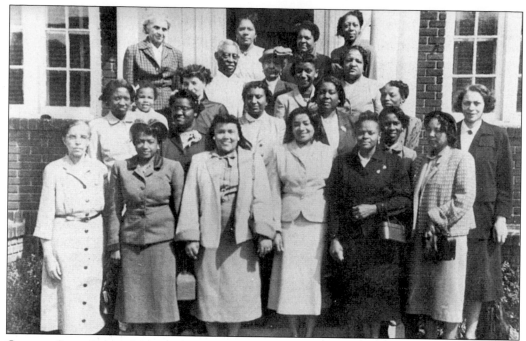

GEORGIA STATE JEANES SUPERVISORS CONFERENCE: 1954. Many key persons made an impact at the state level in education. They were Clara Scott (1916), followed by Miss Lydia Davis Thornton (1919–20), Rebecca Taylor (1923–25), Mary E. Walker (1925–36), Helen A. Whiting (1932–43), Maenelle D. Dempsey (1943–54), Rebecca Davis (1954–63), and Madie Kincy. State Workers were Jeanes Supervisors prior to serving in their state roles; as State Workers, they held higher administrative positions over county supervisors.

HELEN A. WHITING. Helen Whiting was the fifth State Worker. She was the major professor at Atlanta University in the area of administration and supervision. She, along with Dr. Alfonso Elder, developed the first curriculum for the training of administrators and supervisors.

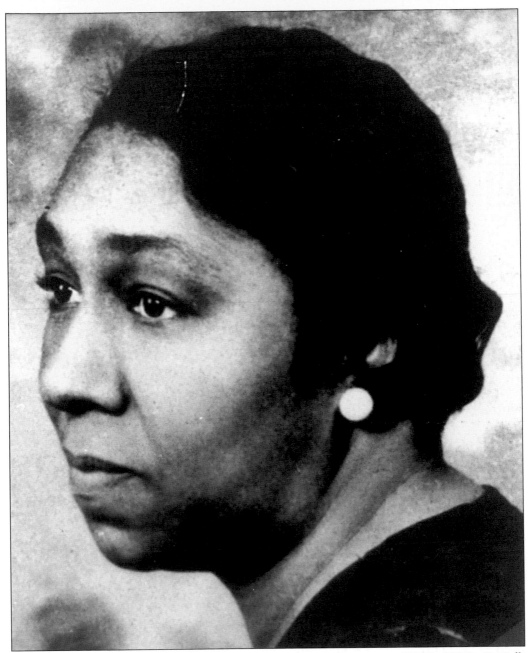

NANNIE CLYDE JOHNSON ADAMS, THE FIRST DEKALB JEANES SUPERVISOR (1923–1938). DeKalb County schools were fortunate to have superintendents who were foresighted enough to employ Jeanes Supervisors, beginning in 1923 with Nannie Clyde Johnson Adams. She worked with Superintendent William Rainey. She taught elementary school in Cuthbert, Georgia, and later returned to Atlanta to accept a position in DeKalb School System. She was the first supervisor for Negro schools in 1923. Mrs. Mills, her counterpart in white schools, shared a courthouse office with Supt. William Rainey. Mrs. Adams's office was in her home. Clyde Adams was a progressive, highly motivated leader of teachers. In 1925–26 she was awarded a fellowship to do advanced study at Hampton University in Hampton, Virginia.

MARIE GAITHER FOSTER, DEKALB INTERIM JEANES SUPERVISOR (1924–26). Marie Foster taught school in many communities throughout Georgia. During her long teaching career, she served as an interim Jeanes Supervisor during Clyde Adams's sabbatical leave. She was instrumental in organizing the community and raising the funds for building the Avondale Elementary and High School (later named Hamilton HS).

ELLA A. TACKWOOD, DEKALB JEANES SUPERVISOR (1938–1940). Miss Tackwood was truly a stalwart educational leader when she served as Jeanes Supervisor in DeKalb schools. She found many schools housed in churches and lodge halls; she worked with the teachers to make the weekday use of the facilities livable. Then on the Friday before Sunday's church service, the classroom environment was removed for church services. Nearly every vestige of the schoolroom disappeared on Friday and reappeared on Monday. Tackwood worked during WW II to get the community to build outdoor toilets and plant "victory gardens." During this period of time, parents and residents in DeKalb were poverty stricken and lacked basic necessities such as paved streets, sewage, and job opportunities. They also lacked the minimal societal needs and comforts for building self esteem and general morale.

DR. FRANKIE GOLDEN ELLIS, DEKALB JEANES SUPERVISOR (1941–1943). The fourth Jeanes Supervisor in DeKalb County was Frankie Golden. She conducted staff development for faculties. She also worked with many community organizations such as PTA, Home Demonstration Clubs, etc. Dr. Frankie Golden-Ellis was a superior supervisor and motivator who was recognized as creative, conscientious, devoted, and diligent. In every sense of the word, she was a leader for excellence in education.

MATTIE BELL BRAXTON, DEKALB JEANES SUPERVISOR (1943–1944). Mrs. Braxton, fifth Jeanes Supervisor, came to DeKalb County in 1943, after serving as Jeanes Supervisor in Montgomery County, Georgia. She was a soft-spoken lady. She went about her tasks working in the 17 schools, surveying the communities, compiling lists of needs to be improved, and setting a plan of action. Narvie Jordan worked under Mrs. Braxton as an intern, and Mrs. Braxton was a Supervisor to emulate. After serving one year, she resigned to return home to Augusta, Georgia. Narvie Jordan was employed in August 1944 to take on the mantle as Jeanes Supervisor.

NARVIE JORDON (HARRIS), JEANES SUPERVISOR (1944–69). Narvie Jordan came to DeKalb on August 15, 1944, eager to begin her new duties as Jeanes Supervisor. She was young, single, attractive, and enthusiastic. She walked into her office at the Cox Funeral Home at 315 Marshall Street, Decatur, Georgia, fully ready to assume her responsibilities which would earn for her the title of "Black Superintendent." And, although the title was an unofficial one, she would in fact play that role for hundreds of people in the years that lay ahead.

Miss Jordan's age was not to be a hindrance. While she was young, she had an air of authority about her and was easily accepted by those much older than she. That was an authority born in the conviction that important work lay ahead, work that was too long left undone, and that there was no time to waste.

She did not know it then, but she would hold conferences with five superintendents over the next four decades. She would lead the effort with others to educate the county's boys and girls for her 39 years in DeKalb County. And although her dreams would never be completely realized, she would see great improvements as a result of her efforts, her drive, her dedication, and her determination.

"The woods were lovely, dark and deep, but she had miles to go before she would sleep, and miles to go before she would sleep."
—An Adaptation of Robert Frost's Poem "Stopping by the Woods on a Snowy Evening"

Three

IN SEARCH
OF THE PROMISE
LIBERTY AND JUSTICE FOR ALL

The DeKalb County School System has evolved into a great system. From the smallest steps to giant leaps in search of a quality education for all children, many stakeholders (teachers, administrators, parents, community, and students) have joined the journey to search for ways to ensure a quality education for all children. One thing is clear; the precursor for liberty and justice in America is education. Relive the history through my personal gallery of images that tell the story of the search for the promise to teach and to learn with unmatched fervor.

Since 1944 when I came to the school district, DeKalb County has grown from a rural, dirt road county to a thriving metropolitan area. There were many turbulent years since 1944 when I entered the county. The earlier years gave me a mission. My tenure in DeKalb Schools was under five superintendents—namely, Mr. William Rainey, Mr. Henry Nelson, Dr. Jim Cherry, Dr. Jim Hinson, and Dr. Robert Freeman. Each has made his mark in the educational history of the school system. The future for education in DeKalb is moving upward, and it will succeed because men and women of goodwill are working together for the good of everyone.

MR. WILLIAM RAINEY (1923–44).

**MR. HENRY NELSON
(1945–49).**

DR. JIM CHERRY (1949–72).

MR. JIM HINSON (1973–80).

DR. ROBERT FREEMAN (1980–96).

In 1944, the education law of the land, "Separate but equal," echoed the corridors of the schools and gave me the momentum to strive for the promise of equality where it counted the most, the classroom. The only thing is, the separate made the equal more difficult to attain. This was serious business for me as I have looked back over those years. We were an invisible segment in the school system. However, I was determined to do my part to improve education in the DeKalb community. My father purchased a 1939 Plymouth for me, and I used the old car to visit schools and homes located all over the county.

Separate was one thing, but disparity was another. I found considerable dissatisfaction among school people and citizens alike regarding the conditions of school buildings, materials, and supplies provided for black children. White children enjoyed better conditions for learning generally than did black children. White children were transported to and from school by buses and received basic supplies; black children received no such services. Black teachers were expected to raise money for chalk, coal and wood for fuel, classroom furniture, and other basic needs. Still other disparities were noted during 1944. Black teachers were paid a lower salary than whites. Health care, nutrition, housing, and county services in general were much less adequate than such services enjoyed by whites. This challenge to improve the lot of the schools and community—to help the people—was met head on by every county nurse, home demonstration agent, minister, educator, and other county agencies; and together we met the challenge!

Not all schools for whites were adequate, by any means. However, most were better than schools for blacks where hand-me-down textbooks and pit toilets were the rule. Redan School, for example, was housed in an old ragged lodge hall.

I have often said of those times, "You could study biology from the floor, wind direction from the sides, and astronomy from the ceiling." It was this kind of truthful humor that kept many educators on the path to find the promise of equality in DeKalb schools.

Lesson: Sprinkle even the most serious situations with humor. And be sure to find a teachable moment even in the face of any adversity.

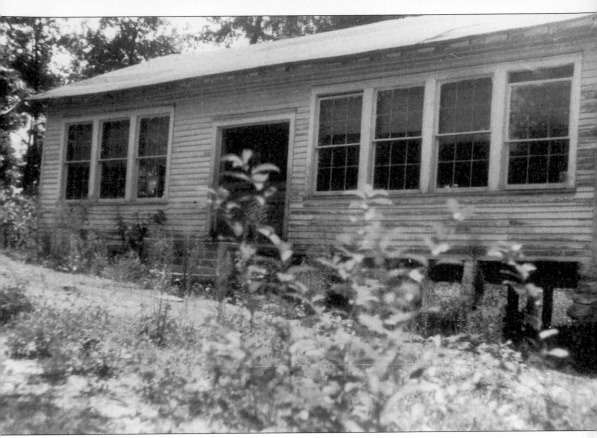

COUNTY LINE SCHOOL (DILAPIDATED SCHOOL CONDITIONS).

Mr. Rainey was previously principal of Decatur High School and superintendent of schools in Lithonia and Kirkwood. He had served as county school superintendent since 1925. Mr Henry Nelson was elected to and took the office as the new superintendent January 1, 1945. He had served as tax collector before opposing Mr. Rainey. Mr. Nelson met with black teachers on February 2 and emphasized those concerns which had been pointed out by me, the Jeanes Supervisor. He asked the teachers to stress "physical and spiritual development, thoroughness, and the ability to get along" to black boys and girls. He indicated that he would recommend to the board of education that it match the funds raised for supplies, similar to the board's matched funding for supplies in white schools. This was a morale boost since all supplies were provided to white schools while blacks received virtually nothing from their tax funds. At least they would now be treated better, if not equally, on this issue by elected board members.

Life was beginning to change all around us. April 1945 was unusually warm as President Franklin D. Roosevelt sat for a portrait at the Little White House in Warm Springs, Georgia. The portrait would never be completed. Georgia and the nation learned of his death April 12, and many from DeKalb County stood vigil at railroad crossings as the train bearing his body passed through Atlanta en route to the nation's capitol. Large numbers of people, both black and white, were on hand to wave a silent farewell as the train passed; its windows were draped in black.

DeKalb's teachers, students, and I heard on August 6, of an aviator, Colonel Paul Tibbet, who delivered the first atomic bomb to a place called Hiroshima, Japan.

That place, the entire city was completely destroyed. The war would come to an end a short time later. I remember, thinking, "Thank goodness! Maybe there would be no more such destruction, no more war." This was a memory I would never forget. Years later, I was compelled to go to Japan to see for myself where the bombing took place—the Arizona Museum at Pearl Harbor.

Under my direction as Jeanes Supervisor, teachers and parents raised $200 for supplies. The purchasing agent refused to take the money we raised.

During this period the DeKalb Grand Jury began its investigation of education; when they convened, they questioned me and many others about the conditions of the school. They then asked me to submit the check to the Superintendent Nelson, who was given one week to provide the supplies for schools for black children. I testified before the Grand Jury, which was looking into disparities between the school conditions for blacks and whites. Published Thursday, February 28, 1946, the Grand Jury presentments painted a rather grim picture of the county's schools for blacks.

"The colored schools, both in buildings and equipment, are in extremely poor conditions. The teaching staff, however, seems to be well prepared and interested in their work. Their school buildings, for the most part, are poor and in some instances are not owned by the county, but are either borrowed colored church buildings or, in some instances, poorly constructed buildings in out-of-the-way places which the colored people have paid for with their own collections. This is a reflection from the good name of our county.

". . . immediate steps should be taken to improve conditions in these schools. Your committee found that these colored children were huddled around defective stoves, and travel as much as five miles without bus transportation and in many cases, without lunch."

In my earlier testimonies, I ensured that the deplorable conditions were discovered and revealed to the Grand Jury. I considered this an important part of my responsibilities to children. I shared the jubilation with parents regarding the Grand Jury's findings. I realized that progress would come slowly, but there was now new hope.

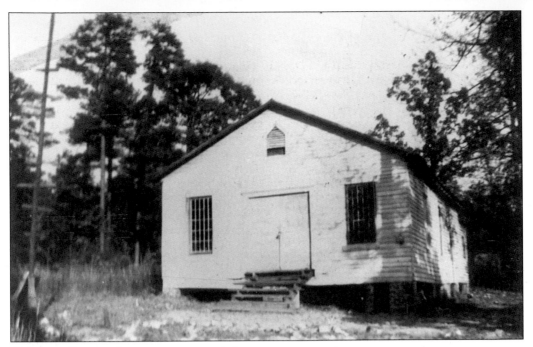

HOPEWELL SCHOOL (ONE-TEACHER SCHOOL).

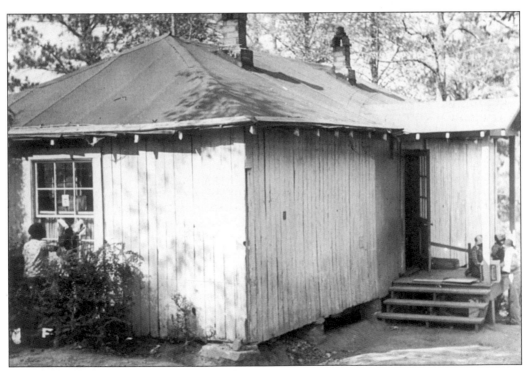

CLARKSTON SCHOOL (ONE-TEACHER SCHOOL).

The DeKalb School district was a political subdivision of the state. Independent schools in the county, including Decatur City Schools, were permitted to operate with a different autonomy. Schools were divided into local school districts. There were 15 such local districts in DeKalb, each having authority to issue local district bonds and levy taxes to pay off those bonds. Each district had separate schools for blacks and whites. An elected board of trustees had authority over the schools within each of the district's boundaries. Each of the local boards of trustees had a supervising principal at the district's high school who was responsible for the high school and its feeder schools. He was, in essence, the local district superintendent, reporting to the board of trustees and to the county superintendent. The principal of the white high school served as an overseer to the colored schools.

Under the new constitution, the local districts were dissolved and the school system became a unified school district answerable to an elected superintendent and a board of education appointed by the Grand Jury. The board was to assume full responsibility for the operation of the system's total educational program in all schools, still black and white however.

The superintendent's records revealed that in DeKalb Schools in 1946, there were 7,500 white students and 1,500 black students enrolled; 262 white teachers (average pay of $131.11 per month) and 41 black teachers (average pay of $73.72 per month).

In 1946, the Grand Jury mandated that on March 2, 1946, there would be a managerial change in the county school affairs. Most of the decision making formerly carried by the local trustees would be shifted to the shoulders of the county board of education. This board would work with the county superintendent, and it is believed that a more uniform system of education would result from the more closely unified supervision. This change was adopted in the new state constitution a year later. The new constitution also established the basis for free public schools for citizens as they are known today, with financing to be the obligation of the state and the expense of which would be provided for by taxation. In practice, however, several years would transpire before the reorganization would begin to meet these expectations.

The Grand Jury of 1946 referred to the need for "an additional Man" to serve as a liaison between the superintendent and the county board of education. On July 1, 1947, Jim Cherry was employed to serve as a consultant to the board. He had been a member of the State Department of Education serving as a high school supervisor. I remember thinking that this young, energetic former naval officer was the right man for the job. I often supplied information about the black schools for Mr. Cherry. He began the process of reorganizing and "plugging" for greater learning opportunities for all boys and girls in DeKalb. I now had two officials to whom I answered—Mr. Nelson and Mr. Cherry. I decided with whom I would conference each Monday based on which of the men's doors were open. If both doors were open, I would leave.

All educators were keenly interested in the process of the reorganization being put into motion. There would be five divisions of administration: (1) Division of Maintenance, (2) Division of Personnel, (3) Division of Transportation and Attendance, (4) Division of Finance, and (5) Division of Instruction. Educators in the schools for blacks wondered how the reorganization would make better school conditions possible for black boys and girls attending the 17 colored schools. Mr. Cherry indicated that he would see to it that all schools in the county would get as much help as possible in providing adequate facilities for the pupils. The black community worked hard to improve the schools. We wanted to take advantage of this drive to let those outside the community know we cared about our surroundings. But there was so little that could be done for those dilapidated buildings during the 1940s. I knew the answer was to consolidate facilities and transport children to larger centers where decent facilities might be provided.

It was obvious to the commissioner of roads and revenue, Scott Candler, and was becoming obvious to the people of DeKalb, that the great inequalities in school tax had to be corrected. The board of education initiated a reform move which would equalize the tax structure and

make available to all citizens, no matter where they lived, an equal education. I knew this was an ambitious plan that would take years to be actualized. Black communities needed sanitation in homes and schools; people needed proper diets and adequate health care; they needed paved streets and proper utilities. Most of all, they needed encouragement.

The uniform tax structure was an added inducement to builders, and with the artificial tax barriers gone, construction was set at an achievable pace. The board would now be able to establish more equality and a standard in school construction, equipment, and services. One school would be able to provide services equal to those of another, at least in theory. The search for equality was still apparent. Many of the board and Mr. Cherry's goals were articulated to the black community by me, the Jeanes Supervisor.

In 1947, I supervised the education of 1,505 elementary and 159 high school pupils in the 17 schools for blacks. Most of them borrowed colored church buildings or poorly constructed buildings in remote areas of the county which colored people paid for with their own meager collections and fund-raisers. Based on the charge of the state (for the use of state MFPE funding to be granted) and Jim Cherry, who served as a consultant for the county, the school centers and I surveyed and made recommendations for consolidating the 17 schools with an eye toward consolidation in 1947–48.

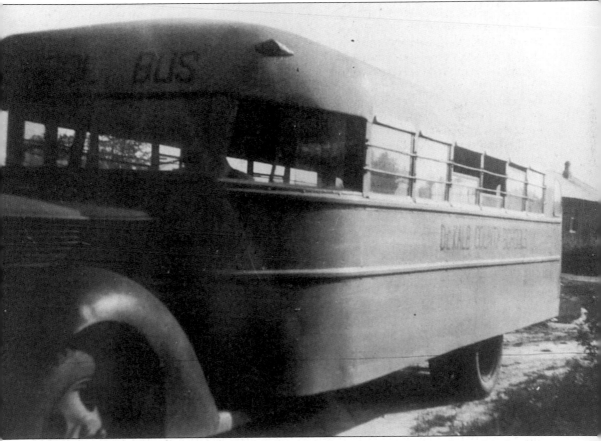

THE FIRST BUS FOR BLACK STUDENTS. The school bus transported black students for the first time in 1948. This was a luxury never enjoyed by black students, and this change would dramatically alter both the number of schools for blacks and their conditions. The first bus provided by the DeKalb County School System transported students from Flat Rock, Miller Grove, Piney Grove, and Redan schools to the Lithonia school in the fall of 1948.

CARY NORRIS, OUR FIRST BUS DRIVER

Public ownership of buses did not come about easily. Owner-operators were opposed to the idea because they could use the vehicles for purposes other than transporting children, and they often did. It was common practice to haul hay, produce, and even chickens between morning and afternoon school bus runs.

Mr. Cherry brought the much needed organization to the school system. There was a noticeable difference in the way things were done. The school system experienced a new organization, and people seemed to know what was expected of them.

In 1948, many new and interesting events surrounded the schoolchildren and society. Coca-Cola was still a nickel and Bing Cosby's *White Christmas* was among the top tunes that year. For a dime, a person could purchase RC Cola and a moon pie. Truman won re-election over Thomas Dewey, the Republican candidate. Veterans received GI loans and bought homes in the suburbs, which came to be known as "fertile acres." Most of these areas were not reserved for blacks.

UNREST IN THE AIR

Other things were brewing. Other educators and I became aware of an increasing impatience with the status quo of the Negro. Teachers were impatient with their lower status than that of their white counterparts. Black parents were impatient seeing their sons and daughters housed in inferior school buildings and receiving less than they deserved. Returning veterans wanted more for their children from the schools than they had received themselves. Black veterans could not find jobs and they could not attend state-supported colleges. Civil Rights organizations such as the NAACP had begun to organize at the local level and to speak out on those disparities. However, there was still a new sense of optimism and hope.

CONSOLIDATION OF SCHOOLS

The first wave of consolidation began in 1948 as a result of the new bus service. Miller Grove, Redan, Piney Grove, and Flat Rock schools went to Bruce Street School in Lithonia. Later Doraville, Mt. Zion, and Mt. Moriah were consolidated with Lynwood Park. Hopewell and Bethlehem were consolidated with County Line School. Tucker students were sent to Victoria Simmons, and students at Clarkston were sent to the new Robert Shaw School in Scottdale. In 1951 the state legislature passed a Minimum Foundation Program for Education (MFPE) which gave capital outlay funds from the three percent sales tax for building construction. As a result, by the end of the final consolidation, all 17 schools for black students were merged into six new centers.

DEKALB COUNTY JEANES SUPERVISORS

NAME	DATES
MRS. CLYDE ADAMS	1923-1938
MRS. MARIE FOSTER (INTERIM)	1924-1926
MISS ELLA TACKWOOD	1938-1940
MISS FRANKIE GOLDEN	1941-1943
MRS. MATTIE BELL BRAXTON	1943-1944
MRS. NARVIE J. HARRIS	1944-1969

DEKALB COUNTY SUPERINTENDENTS

MR. WILLIAM RAINEY	1923-1943
MR. HENRY NELSON	1944-1948
DR. JIM CHERRY	1949-1972
DR. JIM HINSON	1973-1980
DR. ROBERT FREEMAN	1981-1996

SEVENTEEN SCHOOLS FOR BLACKS 1944-1955

NAMES	# TEACHERS	PRINCIPAL
AVONDALE COLORED ELEMENTARY & HIGH SCOTDALE	8	WILLIAM HATTON
BETHLEHEM CHURCH		COLUMBIA DRIVE
COUNTY LINE CHURCH	1	MRS. MELVINA HAWKENS
CLARKSTON SHACKS	1	MRS. MARIE BROWN
CHAMBLEE ROCK BUILDING	8	L.A. ROBINSON
DORAVILLE WOODEN BUILDING HUTCHENS		MRS. WILLIE MAE
FLAT ROCK LODGE HALL	1	MRS. FRANKIE HARDY
HOPEWELL CHURCH	1	MRS. FANNIE EBERHART
LYNWOOD PARK BUILDING	4	MR. ALVIN WILSON
LITHONIA ELEM. & HIGH	1	MR. COY FLAGG
MOUNT MORIAH SCHOOL BLDG.	1	MRS. IRMA BOWENS
MOUNT ZION CHURCH	1	MRS. ELOISE PETTIGREW

ROSTER OF SCHOOLS, NUMBER OF TEACHERS, AND PRINCIPALS' NAMES.

MILLER GROVE CHURCH	1	MRS. GWENDOLYN EALY
PINEY GROVE CHURCH	1	MRS. JULIA THOMPSON
REDAN LODGE HALL	1	MRS. EMMIE SMITH
STONE MOUNTAIN ROSENWALD	1	MISS JULIA JOHNSON
BUILDING		MR. EDWARD BOUIE
TUCKER SHACK	1	MRS. FANNIE DOBBS

DEKALB CONSOLIDATED CENTERS

BRUCE STREET COMBINATION	MR. COY FLAGG
COUNTY LINE	MRS. FANNIE EBERHART
HAMILTON HIGH	MR. WILLIAM HATTON
LYNWOOD PARK COMBINATION	MR. L . A. ROBINSON
VICTORIA SIMMONS	MR. EDWARD BOUIE
ROBERT SHAW	MRS. EVELYN RIGGINS

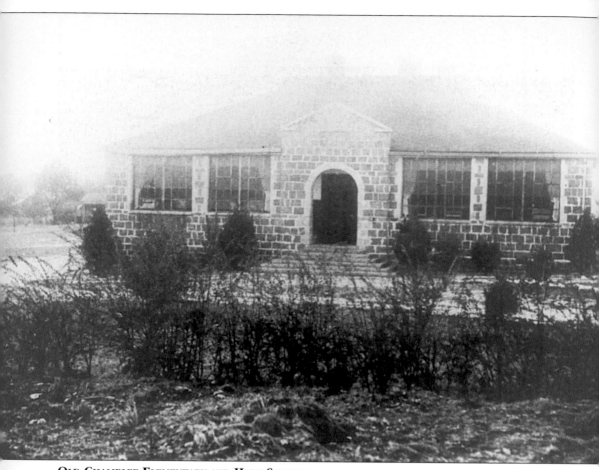

OLD CHAMBLEE ELEMENTARY AND HIGH SCHOOL.

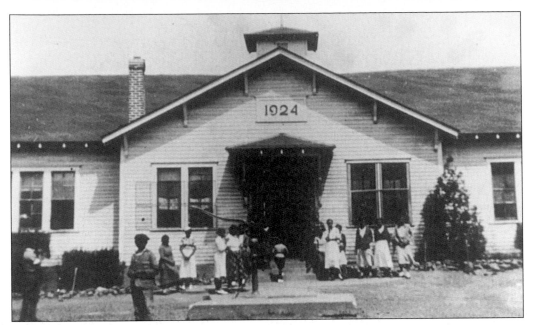

AVONDALE ELEMENTARY AND HIGH SCHOOL.

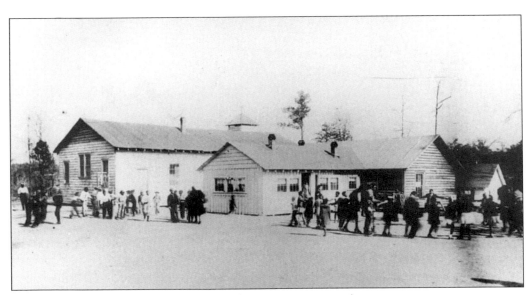

RECREATION TIME AT TUCKER ELEMENTARY (ONE-TEACHER SCHOOL).

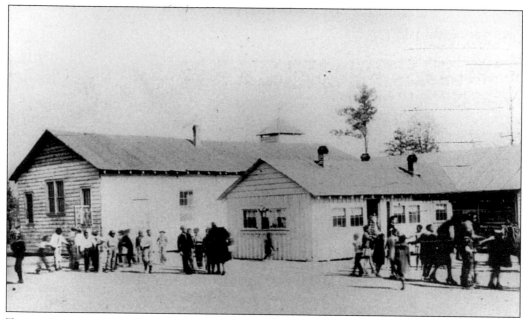

TUCKER ELEMENTARY.

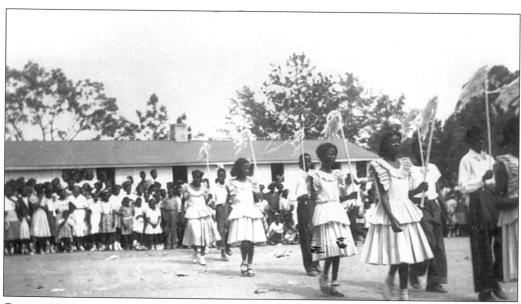

COUNTY MAY DAY, BRUCE STREET HIGH SCHOOL, CREPE PAPER DRESSES. The county-wide May Day was an established county activity when I arrived in DeKalb schools. Most were held in a Stone Mountain ball field. Bruce Street also offered May Day activities. Physical fitness was the focus of the field day activities.

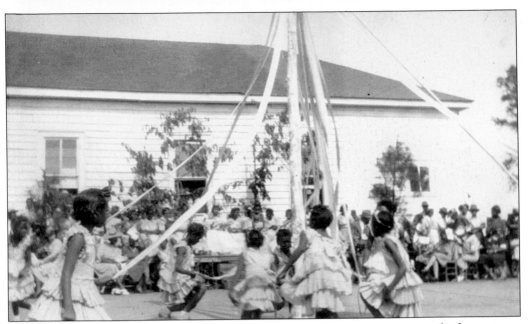

COUNTY-WIDE MAY DAY AT BRUCE STREET (LITHONIA). The dresses were made from crepe paper.

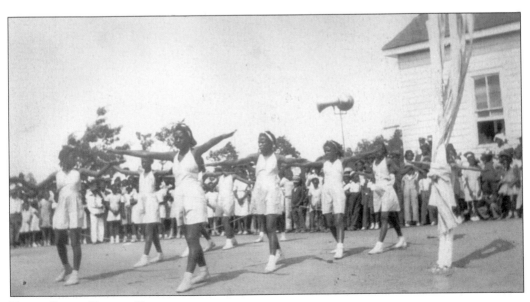

BRUCE STREET FITNESS DEMONSTRATION.

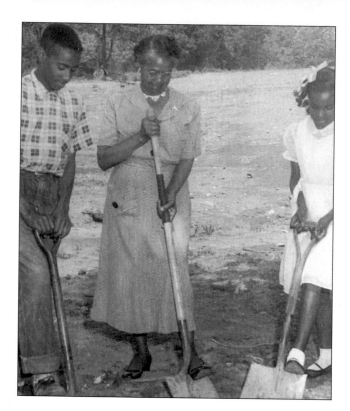

GROUNDBREAKING. Originally Stone Mountain Elementary, this site would be the new Victoria Simmons Elementary School.

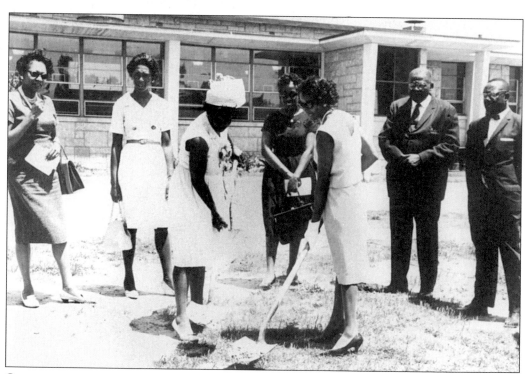

GROUNDBREAKING FOR NEW BRUCE SCHOOL.

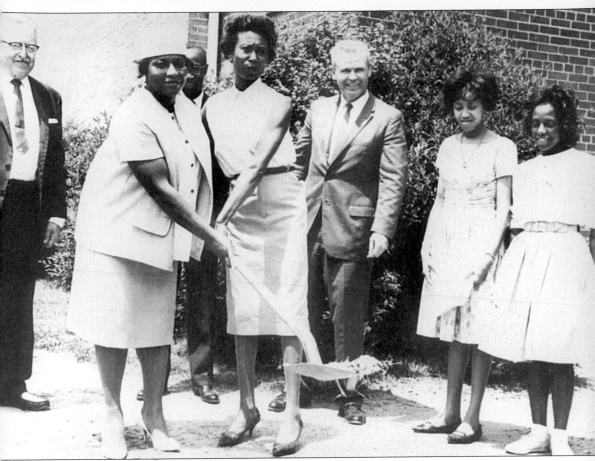

GROUNDBREAKING FOR THE NEW HAMILTON HIGH SCHOOL. This was originally Avondale Elementary and High School. Gussie Brown, PTA president (second from left), and Jim Cherry, superintendent from 1949 to 1972 (fourth from left), are pictured.

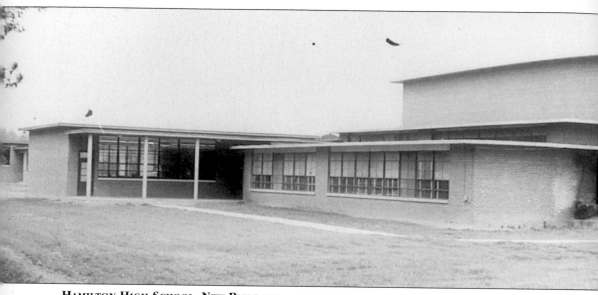

HAMILTON HIGH SCHOOL: NEW BUILDING.

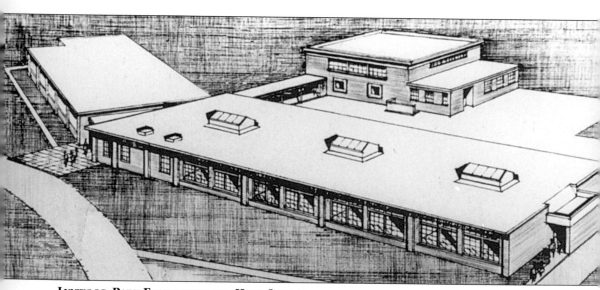

LYNWOOD PARK ELEMENTARY AND HIGH SCHOOL.

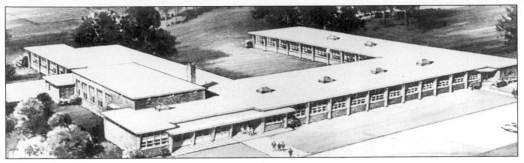

ROBERT SHAW ELEMENTARY.

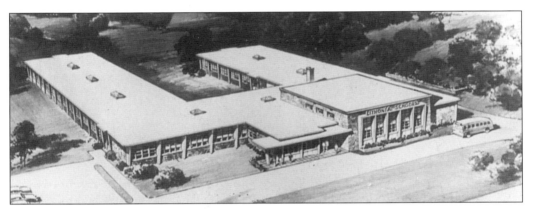

BRUCE ELEMENTARY AND HIGH SCHOOL.

PROFESSIONAL TEACHER ORGANIZATION SETS PACE FOR EQUALITY

The atmosphere was one of unrest, change, and yet hope in DeKalb County when three teacher delegates attended the Georgia Teacher Education Association Convention (GTEA) in Augusta, Georgia, April 1949. Fannie Eberhart, Allie L. Rollins, and E.C. Riggins returned to tell of the planned court action aimed at testing inequalities and discrimination in education at all levels.

THURGOOD MARSHALL PROMOTING THE EQUITY AGENDA IN EDUCATION

On Friday night of the GTEA 1949 Convention at the Atlanta City Auditorium, Attorney Thurgood Marshall spoke enthusiastically about the many inequalities blacks suffered as a race. He urged all teachers to be as interested in their own welfare and to be prepared to fight financially and mentally to attain equity in the schools. He reminded us of the deplorable work conditions in which we worked, but we failed to complain for the fear of losing our jobs. He told us about the court actions being waged against Atlanta for the rights of teachers and students. He told us about the various petitions filed by the NAACP to fight the battle of the Negro teachers. The GTEA Convention closed by calling on the Board of Regents to accredit the three colleges (Fort Valley, Albany, and Savannah State Colleges) for Negroes and to provide within the state the same type, level, and quality of graduate and professional opportunities. They asked the state to (1) eliminate all differentials in state salary schedules for teachers based solely on race, (2) establish a policy on alloting state funds for free textbooks and library books on an equitable racial basis, (3) provide Negro youths and adults vocational education at state level equal to that provided for whites, and (4) provide Negro blind and deaf facilities. City and county boards of education were asked to establish policies which would be applied in exactly the same manner to the affairs of Negro and white schools as related to scope and quality of curriculum, pupil-teacher ratios, grade levels of school programs, school plant consolidations, length of school day, length of school term, and school plant maintenance.

The resolutions were adopted by the members of the delegate assembly and were heralded as the first step in attaining educational equality in the State of Georgia.

With the process of reorganization nearing completion, Jim Cherry was elected superintendent of DeKalb County schools. He won the office on January 1, 1949, without opposition, since Nelson withdrew his candidacy just prior to the qualifying deadline. Mr. Nelson had served one term in the superintendency.

As the school system and superintendent were making a transition, the veterans were also making a transition as they returned home in large numbers from tours of military service (also under a segregated system). They also brought home new motivation for education. They learned the value of education while in service. They brought home a thirst for education; many returned to school, used their GI bills to attend college, or attended organized classes at Avondale, Bruce Street, and County Line schools to study farming, brick masonry, etc.

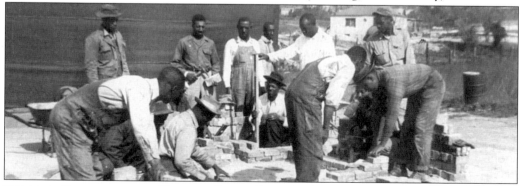

VETERANS RETURNING FROM MILITARY TOURS TAKE CLASSES TO BUILD SKILLS (BRICK LAYING). Evening classes were offered at Bruce Street, Avondale, and County Line schools.

EQUAL WORK WITHOUT EQUAL PAY

The parents of 1,972 black children in segregated schools, taught by 49 teachers, equally supported the bond issues. They equally attended meetings and equally spread the word regarding the passing of the MFPE funding from the state. But they did not share equally in the gains. Not yet, anyway, I remember thinking at the time. Jim Cherry seemed painfully aware of the disparities in his own county and spoke to professional organizations and others candidly about the issue. He proved himself to be an advocate for all children. He won the following of many county educators. I realized that my recommendations were not only heard but acted upon.

THE EARLY PROGRESSIVE 1950s

The early 1950 newspapers carried headlines about the attack on South Korea by its northern neighbor. Humphrey Bogart was selected best actor in 1951 for African Queen. Vivian Lee won the award for her role in *A Streetcar Named Desire*. Dwight D. Eisenhower was elected president in 1952. Ralph McGill, editor of the *Atlanta Constitution*, was a recognized spokesperson for equality of educational opportunity for all children. The Negro still did not exist as people of the mainstream of America. There was a new affluence on the rise. Television urged Americans to "see the USA in a Chevrolet." Advertisements showed appliances. The family of four could get by on $60 per week. Unfortunately there were not many black families in DeKalb County who had such earnings.

I can remember having so many strong feelings about the times and the events aligned to that period. I remember being so very proud to be a part of DeKalb County, the first Georgia county to provide transportation for black students and the first to equalize teacher salaries. Developments became swift in the early '50s. Capital outlay funds were available, which set into motion a rash of new school construction. The courtroom became a battleground by the black community in an effort to share in the new opportunities for education.

But as a result of May 17, 1954, the clouds of controversy had reached tornado levels when the U.S. Supreme Court ruled in Brown vs. Board of Education that segregated schools were unconstitutional. In that one ruling, Georgia's separate-but-equal law, that had existed as a reflection of the South since 1870, was wiped off the books. But I knew from a past of anxiously waiting for "things to improve for our children" that compliance would again take time even though the wise men of the Supreme Court directed that desegregation be brought about "with all deliberate speed."

Lesson: All deliberate speed can sho' be awfully slow.

CHANGE AND ITS UNEASY RAMIFICATIONS

The new ruling created deep conflicts among people. It split old friendships, political alliances, on-the-job working relationships, and it pitted one race against the other with a new, overt intensity. On the other hand, it also forced some educational leaders, both black and white, to face the facts that how they perhaps were reared and where they were raised may have conflicted with their consciousness and deeper sense of integrity. I prayed that the small gains would not come to a halt because of the resentment of the court's ruling. I realized the separate-equal movement had caused irreparable damage, but I still had hope that the children would eventually be allowed to become all they could be.

I called on whites to be involved with education more than ever. I began to call on teachers to work harder and create more activities to augment the main curriculum. These activities were designed to build a sense of community, which helped children feel better about themselves, their schools, and their homes. The many projects were an effort to get people together and let them share in the joy and the satisfaction that comes from collaborating toward a common goal.

Lesson: Cooperative learning is not a new method of teaching. Interdepending on each other for the common good of us all is how many people have reached goals for centuries.

For much of the curriculum and many enrichment activities, we lacked equipment, facilities, and supplies, but we were resourceful to find means and ways. There were no science labs, no gyms, no technology, limited supplies, etc.

Lesson: Effective teachers do not make excuses about what they lack for teaching children; instead, good teachers can take straw to make bricks.

We taught students lunchroom and assembly manners. The cafeteria served for many activities other than for dining. PTA meetings, assemblies, music, drama, and exhibits—to name a few—enlarged the varied activities in our schools through the use of our cafeteria space. Nutritious, attractive type-"A" lunches were served. I attended State Lunchroom Workshops, and later I returned and held workshops with our lunchroom workers. I discussed menu planning, dress, and cleanliness, and I was able to employ consultants to conduct these workshops. I also used the services of the state lunchroom consultant.

Controlled heat in our new buildings was a blessing from the use of pot belly stoves. Also, I was able to get the board to hire custodians and maids to keep the buildings, grounds, and equipment clean.

In communities, roads were paved and lights and sewer installed—all added to the beauty of the communities. Still later and often simultaneously, homes and small businesses took on improved appearances.

The DeKalb County Home Demonstration Agent, County Public Health Nurse, and myself used the team approach as we worked community improvements. The churches joined our team too. Better trained ministers came to churches and used the pulpit to get the word out to residents.

I sought help from community agencies, welfare, and family and children services. We met Mrs. Caroline Clark, director of Family and Children's Services, American Red Cross, etc., for indigent residents. I secured from private sources items needed for our families. During these early years, the total population of blacks was very small.

The newly consolidated school meant there were no schools for blacks as we had known them in the past. The curriculum, the enrichment courses, the extracurricular activities, and every facet of school changed. How we worked with children and adults took on new meaning.

SCIENCE AND SOCIAL SCIENCE FAIRS
In the 1940s I initiated local and county-wide science fairs, and I provided inservice for teachers to strengthen their skills in science education. I used what we had available since facilities were limited in the early '40s. Consultants from Atlanta University Center were used to teach science. The Science Fairs continued to be a viable curricular project in the county.

In order to expand and enrich the curriculum in all grades, workshops for staffs were held in the area of Social Science disciplines. The teachers in elementary and secondary schools met, planned, and sponsored Social Science Fairs held at Robert Shaw School. Students prepared locally for the county exhibition and judging of the projects at the county-wide fair to determine the best projects in the county. Teachers displayed projects for a week; teachers took students on field trips. Parents and the general public were invited, and much enthusiasm was generated by staff, parents, and the public.

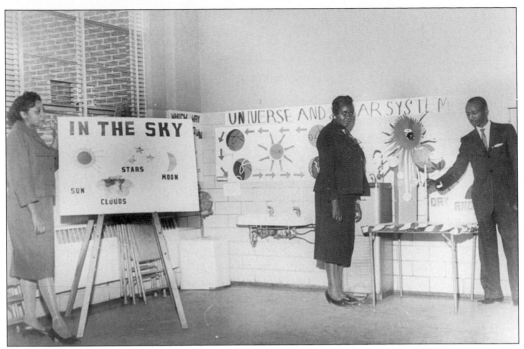

SCIENCE FAIR. Pictured here from left to right are Narvie Harris, Ruby Moss, and William Hatton.

JUDGES FOR THE COUNTY-WIDE SCIENCE FAIR (1958).

BINNEY SMITH CRAYOLA ART WORKSHOP FOR TEACHERS, 1952. Teachers are being inserviced how to enhance classroom instruction (conserving materials, creating materials, etc.).

ART EXHIBIT AT ROBERT SHAW. Art Week was held in each school prior to the Christmas vacation. Themes were based on the holiday season and gave children an opportunity to show their creativity and to develop art talent using the most basic materials.

AMARYLIS HEARD, HOME ECONOMICS TEACHER, AT LYNWOOD PARK HIGH SCHOOL. Home Economics was added to the curriculum.

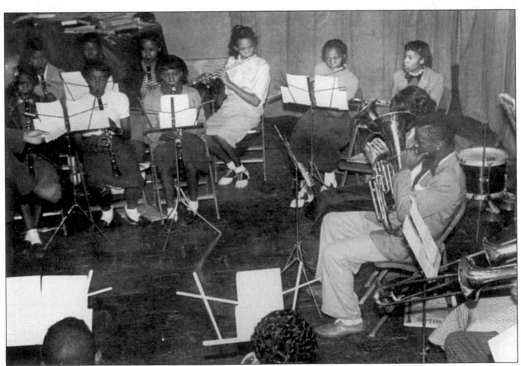

HAMILTON HIGH SCHOOL BAND, DIRECTOR WILLIAM BRAYNON. William Braynon, director, instructed students in the three high schools: Lynwood, Hamilton, and Bruce Street.

CHORAL MUSIC CLASS AT HAMILTON, MR. WELLS, TEACHER. Each of the high schools offered a choral music class. Many students participated in the state competitions.

CHORAL MUSIC CLASS AT HAMILTON HIGH SCHOOL.

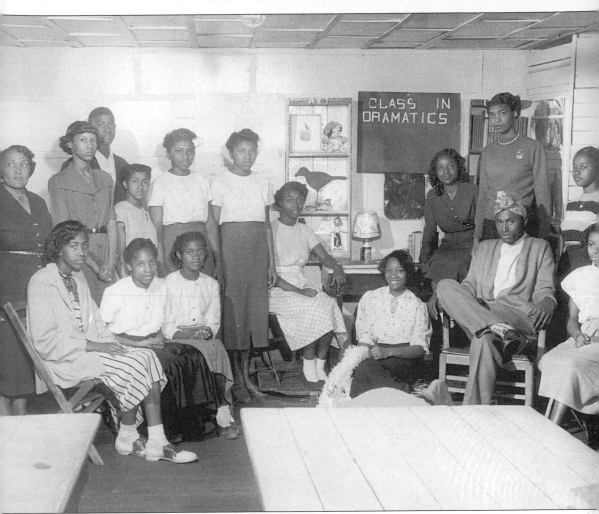

DRAMATICS AT HAMILTON HIGH SCHOOL, 1940s. Pictured from left to right are Mr. Luther Stripling (in fancy turban), Menona Hammond, Sylvia Mosely, and Joyce Thomas. Drama was also an offering that allowed still another venue for creative expression.

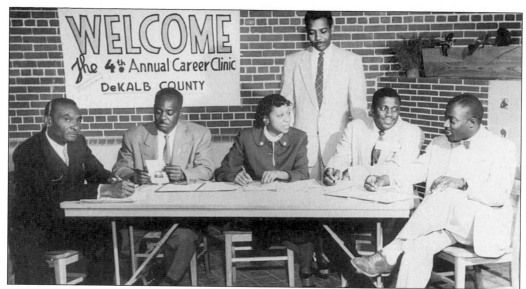

CAREER CLINICS. The clinics enabled people to see hope for their futures and provided a background of experiences for children. They also gained exposure to new aspects in life never experienced until the Career Clinics provided new awareness and training. From left to right are (sitting) Clarence Howell (Bruce Street HS teacher), Lucious Robinson (Lynwood Park HS principal), Narvie J. Harris (supervisor), Jimmy Johnson (Hamilton HS art teacher), and Robert Harvey (Hamilton HS social studies teacher); (standing) George Gholston (Lynwood Park HS social studies teacher).

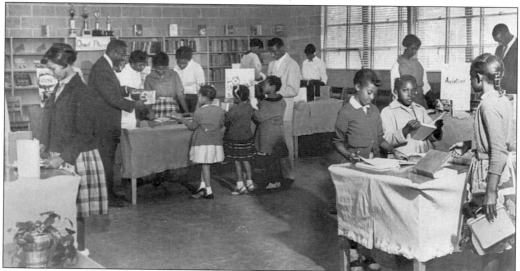

COUNTY-WIDE HOBBY SHOW AT HAMILTON HIGH SCHOOL INVOLVING EACH SCHOOL COMMUNITY. All learning does not revolve around academics. Children must be able to excel in other areas and to be given recognition for other proficiencies. Teachers attended staff development sessions to learn how to help students develop their hobbies. Hobby Shows allowed students to share other talents. Students, parents, and community residents enjoyed displaying their hobbies of collections of cups and saucers, old cars, planes, etc. This affair brought people together in the community for enrichment and aesthetic appreciation. The hobby shows followed a theme.

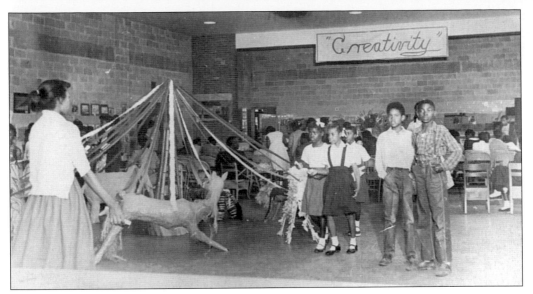

HOBBY SHOW THEME: CREATIVITY.

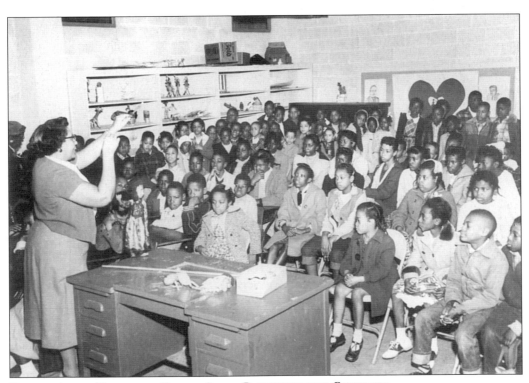

PAULINE ALLEN, TEACHER AT ROBERT SHAW, DEMONSTRATING CREATIVITY.

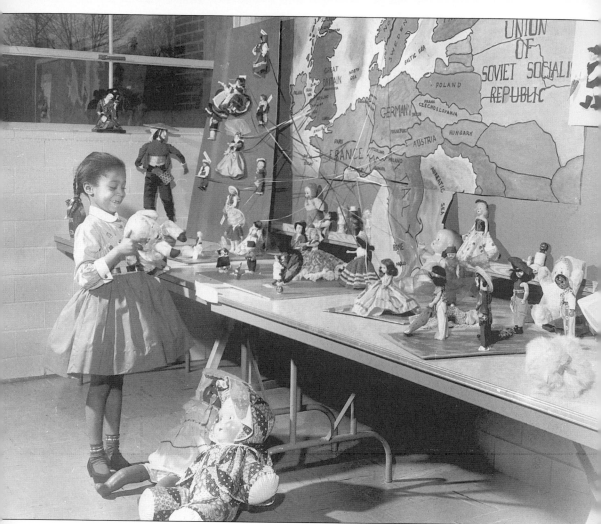

COUNTY-WIDE DOLL SHOW AT VICTORIA SIMMONS SCHOOL: DARYLL HARRIS'S DOLL COLLECTION, 1956. Daryll is the daughter of Mrs. Narvie Harris. In January, the Doll Show was a community activity to build aesthetic appreciation. Students exhibited their dolls in various categories: large, small, beautiful, ugly, bridal, Barbie, etc.

WILLIAM TURNER, FIRST SPECIALIST FOR HAMILTON HS: HEALTH, PE, AND ATHLETICS, 1958. From left to right are Principal William Hatton, Connie Lester (Girls' PE teacher), two unidentified students, William Turner (teacher/coach), and Narvie Harris.

The first specialist employed was in the area of health and physical education. Mr. William Turner, 1948 graduate of Morris Brown College, was assigned to Hamilton High in 1955. He was a teacher of health and physical education and a coach. Mr. Cherry emphasized that Mr. Hatton must build an exemplary program for boys and girls. Teachers later would be extended to Lynwood and Bruce High Schools. Mr. Cherry stated the prime purpose would be to develop a program of health and physical education in order to improve the mental and physical health of the students.

BAND INSTRUCTION
The next specialist employed was Mr. William Braynon, also a graduate of Morris Brown College. He developed bands during the early years at Bruce, Lynwood, and Hamilton High Schools. He was not given musical instruments, but working with the students and parents, he motivated them to first rent them with the option to buy. From a meager beginning band, we grew in membership at each school. They became a member of Georgia Band Association and brought home top superior ratings when they attended state band contests. Students who were trained by such dynamic musicians, many who owned bands, earned Ph.D.s, taught in colleges, etc. (Wallace Jones, Luther Stripling). Later the board of education employed band directors for each combination high school and employed additional instructors for elementary students. Later band instructors offered band and also strings classes to all students in DeKalb schools.

HOMEMAKING AND INDUSTRIAL ARTS
In homemaking, Miss Juanita Jackson, graduate of Savannah State College, was assigned to Hamilton High School where she taught classes to boys and girls. Mr. James Smith, graduate of Tuskegee Institute, served as our first Industrial Arts teacher at Hamilton High. Each of

these specialists hired pioneered at Hamilton. Later the programs were extended to Bruce and Lynwood Park High Schools. Hamilton was chosen to lead because it had the largest school population and had a dynamic principal in Mr. William Hatton.

Other specialists included the following: Two speech therapists were employed to serve schools. The first two were Miss Annie Rambo and Mrs. Jessie Bell, still later, Mrs. Amaralysis Hawk was employed. Homebound Instruction was added with the employing of Mrs. Alyce Ware. Then driver education became a part of the curriculum as Mr. Edward Chatman served as our first teacher. All of these specialty areas first were housed at Hamilton High School.

Reading was a priority. Our first improvised reading center was at Bruce School, Mrs. Joyce Carver, teacher. Still later, the board of education employed Mrs. Gwendolyn Drayne, a reading specialist from Hamilton High. Later I trained teachers in each school to help identify pupils with reading problems. Mrs. Juanita Anderson was the first black teacher assigned to the DeKalb County Reading Center in Clarkston initiated by Dr. Robert Aaron, followed by Dr. Estelle Howington.

OTHER ADJUSTMENTS AND NEW TEACHINGS

Students and faculties occupied in new edifices was truly a historic occasion for black students in DeKalb. Pupils were fascinated with flush toilets; they were often found flushing the water to hear and see this new thing. Cafeterias were in all buildings. Florescent lights, venetian blinds, tiled floors, teachers' lounge, and principal's office were in all schools. This was truly a new day.

Continued inservice was needed. Georgia Power Lighting specialist gave instructions on the use of natural lights. She used a light meter to identify the dark areas in the room, near the door and on the floor. Teachers also needed tips for seating children in relation to the teachers' desks. They advised teachers not to let the students face the daylight, even on cloudy days because of the intensity of outdoor light.

Controlled heat in our new buildings was a blessing from the use of pot belly stoves. I was able to get the board to hire custodians and maids to keep the buildings, grounds, and equipment clean.

JEANES SUPERVISOR DR. FRANKIE GOLDEN ELLIS (BEFORE NARVIE HARRIS), 1930–40s. North DeKalb County Inservice's emphasis was on "Creative Teaching."

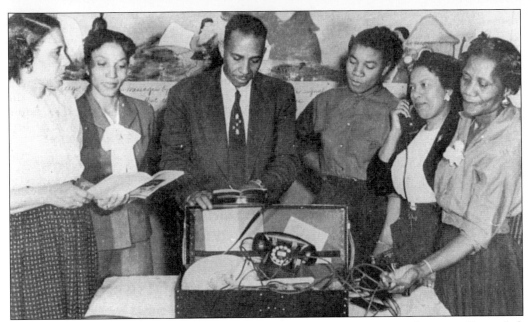

LEARNING TO USE THE PHONE: FACULTY INSERVICE AT COUNTY LINE SCHOOL. From left to right are Lottie Moseley, Frances, Culbreth, John Lovejoy, Julia Mitchell, and Fannie Eberhart. Southern Bell provided kits to train teachers to use the telephone in order to instruct their students.

VICTORIA SIMMONS FACULTY, 1955.

ALL COUNTY-WIDE FACULTY ATTENDS THE 1950 MUSIC FESTIVAL FOR STUDENTS. Decatur High School Auditorium was the setting.

TUITION GRANTS FOR TEACHERS
The board (through Mr. Cherry) provided tuition grants for teachers to attend training at Atlanta University. Because of the separate-but-equal laws, black teachers could not attend the Emory teacher training workshops. The first area of study was in Special Education in 1954. Later, other subject areas were "new" math, reading, testing, etc.

ADMINISTRATORS' WORKSHOP
I was aware of an Administrators' Summer Workshop for white principals, held at Dunaire School, but I was not a part of it due to a dual educational system.

Again I requested, in 1955, Mr. Cherry and the board of education to pay for a similar workshop for blacks. He replied positively with the stipulation that it be held in DeKalb County. We contacted President Clements of Atlanta University. He assigned Dr. Linwood Graves, professor in administration. The workshop was held at Hamilton High School. I also used state department of education consultants. Mrs. Graves, wife of Dr. Graves, served as our secretary-gratis.

GEORGIA ACCREDITATION
The school population for blacks continued to escalate. I was able to recommend additional teachers who were better qualified. The high schools applied for accreditation through Georgia Accrediting Association. We met the requirements with assistance from the DeKalb Board of Education. We increased subject offerings and also received additional equipment.

COMMUNITY RESOURCES
I sought help from community agencies, welfare, and family and children services. We met Mrs. Caroline Clark, director of Family and Children's Services, American Red Cross, etc.,

for indigent residents. I secured from private sources items needed for our families. During these early years, the total population of blacks was very small.

LEARNING TO SPEAK THROUGH THE VOTE

Also during the early years, we encouraged blacks to become registered voters. When students reached 18, the social studies teachers accompanied them to the DeKalb Courthouse to register—parents registered too. Community morale was growing as well as the spirit of cooperation. More students were staying in school. Beauty in the homes and schools became a priority, and public utilities that were installed made communities better places to live.

MS. BUTLER, FIRST PRESIDENT TO THE STATE AND NATIONAL PARENTS AND TEACHERS' CONGRESSES. Parent-Teacher support groups were still separate. Mrs. Salena Sloan Butler organized the first PTA unit at Yonge Street School, in Atlanta, where Miss C.B. Finley was principal. Mrs. Butler was concerned about the children in the southeast area of the city. She organized and became the first president to the State and National Congresses of Colored Parents and Teachers.

I became more active with the State and National PTA Congresses and attended their conventions. In 1953, I was unanimously elected president of the Atlanta District PTA. PTA Council members took an active role when DeKalb County Schools Visiting Committees met to evaluate our high school and elementary schools. I followed the State PTA Congress theme for the year as I promoted PTA work in the district. All district presidents became members of the State PTA Board of Managers. I held several standing committee posts on the state level.

Still later I was elected state secretary, vice president, and served as the 12th and last president of the Georgia Congress of Colored Parents and Teachers' Board (1967–71). All the state PTA served the National Congress of Colored Parents and Teachers' Board until its demise in 1970. The PTA Council was a dynamic, forceful organization interested in the promotion and welfare of children and youth.

From 1962 to 1966, early years of the annual PTA Council, banquets were held and continue to be a practice today.

BOARD MEMBER MAKES HISTORY

Until 1983, the board of education membership was totally white. Mr. Phil McGregor came on board as the first black member. This was a "new day" because he was present, visible, and vocal, and gave us representation at the decision-making level. Mr. McGregor also served as chairman of the board. He remained a member of the board until 1998 (serving for 15 years). In 1999, the board of education voted to rename the District Office Instructional Building (Building B) in honor of Phil McGregor. The new name is the Phil McGregor Center for Instructional and Curriculum Development.

5 25 '98

PHIL MCGREGOR, FIRST BLACK TO SERVE ON THE BOARD OF EDUCATION. He served on the board for 15 years. He is known as a man who could take an unpopular stand if it means the good of the boys and girls of DeKalb County. He left his board of education post being called a man of great insight, great skills, and uncompromising integrity. The Phil McGregor Center for Instructional and Curriculum Development (1999) was named to honor his great work.

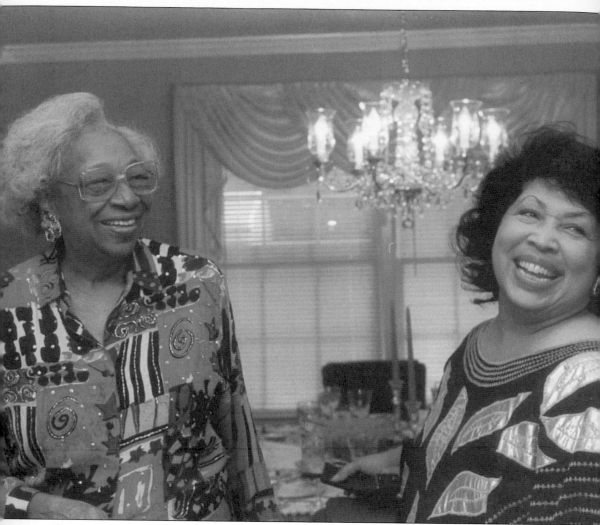

NARVIE HARRIS (LEFT) WITH FRANCES EDWARDS, FIRST BLACK FEMALE BOARD MEMBER WHO ALSO SERVED AS CHAIRPERSON DURING HER TENURE. Mrs. Frances Edwards was elected the first black female to serve on the board of education. She also served as chairperson. She is known for the successes she has accomplished for the boys and girls of DeKalb. People are drawn to her because of her vision, political savvy, her contagious interpersonal skills, and her captivating personality.

The educational journey to excellence was not traveled by one or two persons. It began in 1923 with five superintendents and six Jeanes Supervisors, along with several dedicated classroom teachers, principals, community persons, and agencies.

Key African-American participants included the following persons who made contributions beyond measure and the call of duty:

Mr. William Hatton, principal of Avondale Colored School (later named Hamilton High School), was pioneer for educational leaders in DeKalb. His vision and unmatched ability to caucus the community to positive change will long be remembered. Able to motivate diverse groups of community and school people, he was a collaborative leader long before autocratic leaders lost their appeal. Organized, academically prepared, and astute are traits that convinced the community to name a street in his honor, Hatton Drive, located today near Robert Shaw Theme School. On May 17, 1954, Mr. Hatton and Mrs. Harris were together at Victoria Simmons when the Supreme Court decision sent the shocked media press for comments.

Dr. Edward L. Bouie Sr., former principal at Stone Mountain Colored Elementary (later called Victoria Simmons Elementary) and Robert Shaw Elementary, instructional supervisor in social studies, assistant superintendent, and associate superintendent, influenced many people through these major administrative positions. He was able to make significant impacts related to major school policies, especially those pertinent to African-American students. He is remembered for his effective leadership in setting high standards for students, teachers, and administrators and making provisions for which those standards could be accomplished.

Many educators paved the way as DeKalb County leaders. Jesse Dixon was a key player in the history of African-American education in DeKalb County. He served as a teacher, principal, instructional supervisor of mathematics, and director of Title I Services. His versatility, academic skill, and ability to facilitate other professionals to excellence are influences still remembered in the system today. His quick wit coupled with ingenuity gave him many advantages in motivating people of different skill levels to do great things for children. Eugene Thompson was also a champion who made history as the first black assistant superintendent. He was able to encourage (and enable) many outstanding educators to strive for higher positions in the district. Earlier he impacted the sports and the physical education curriculum as the county's athletic director. As a significant "mover" in the Minority-to-Majority Movement (M-to-M), he enabled many parents and children to access educational choices once denied.

Fortunately, we have had many other strong men and women on the board of education and in the DeKalb County district office who worked successfully with the five superintendents for the growth of the school system. Today, many African-American district-level administrators have achieved leadership positions such as deputy superintendency (Dr. Melvin Johnson, Dr. Mary Maynard, Dr. James Williams, and Dr. Eugene Walker). Several others serve as Executive Directors of Instructional Teams, Instructional Coordinators, Directors, and specialized teacher-leaders. Many of the aforementioned are direct beneficiaries of the pioneer efforts of my educational and community contemporaries. DeKalb citizenry has also been highly supportive of the school system. Parents have been involved in plans for their children's education. Thus, they know what has gone on in our schools. They served as active volunteers, were members of the PTA, served on committees, and totally committed themselves to a good school system through their finances, especially their voting for bonds and the levying of school taxes.

SCHOOLS NAMED TO HONOR AFRICAN AMERICANS IN DEKALB COUNTY

I applaud DeKalb County Schools for recognizing my efforts and the efforts of four other DeKalb African-American educators by naming schools in our honor. In the 1950s, the Stone Mountain community recommended to the DeKalb Board of Education that the Stone Mountain Elementary School be named for a former female student—Victoria Simmons. Again in the '50s, when schools were constructed, the Scottdale community recommended to the board that the Avondale Colored Elementary School be named for Mr. Robert Shaw, a community leader who donated land to the board of education. In 1999, the community recommended the reopening and renaming of the school currently known as the Robert Shaw Traditional Theme School. The many contributions of Mrs. Maude Hamilton, principal of Avondale Elementary and High School, are reasons for naming the Scottdale community school Hamilton High School.

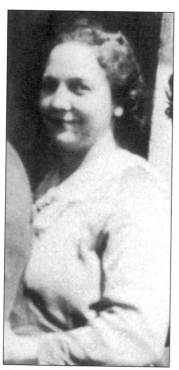

Left: MRS. MAUDE HAMILTON, FORMER PRINCIPAL OF AVONDALE ELEMENTARY AND HIGH SCHOOL DURING SEGREGATION YEARS. *Right:* DR. EDWARD L. BOUIE SR., FORMER ASSOCIATE SUPERINTENDENT FOR DEKALB COUNTY SCHOOLS. In the memory of Dr. Edward Bouie Sr., a former principal of Victoria Simmons and Robert Shaw Elementary Schools, and associate superintendent, the Edward L. Bouie Sr. Traditional Theme School honors his work in DeKalb County.

DR. ELDRIDGE MILLER, PRINCIPAL OF THE ELDRIDGE MILLER TRADITIONAL THEME SCHOOL. In memory of Dr. Eldridge Miller, former teacher, coach, and principal of Southwest DeKalb High School and Mainstreet Elementary, Mainstreet Elementary now holds the name of Eldridge Miller Elementary School (1998).

I arrived in 1944 a young teacher eager to serve the boys and girls of DeKalb. I retired proud of the accomplishments that I and so many others achieved together. I am proud to accept "the rare flowers given to the living" in the naming of the Narvie J. Harris Traditional Theme School.

MRS. NARVIE J. HARRIS AND DR. JAMES R. HALLFORD, THE SUPERINTENDENT OF DEKALB COUNTY SCHOOLS, AT THE BUILDING SITE FOR THE NARVIE J. HARRIS TRADITIONAL THEME SCHOOL. Under Dr. Hallford's leadership, the school was nominated, named, and constructed; it opened August 1999. I express my sincere admiration and gratitude for all that he has and continues to do in raising the bar for quality education in DeKalb County for all boys and girls. It is under Dr. Hallford's leadership that the close of this millennium will end "the early chapters" of DeKalb's educational journey and will now give rise to DeKalb schools of "the next chapters," focused on preparing students for the 21st century.

Lesson: Service is the rent one pays for the space one occupies.

Many educators, community and children advocates, including me, came, worked, and felt the personal mission to serve—realizing the essence of true leaders is one who can serve for the good of all. These missions of serving can and did make the difference in DeKalb.

As I neared my retirement, I thought of the past 39 years in the DeKalb School System. I thought of the lessons I learned.

The Ultimate Lesson for Me: May we all walk that walk and talk that talk with the Master Teacher who loves us all, forgetting the evil things, and pressing us forward to the highest mark of any pupil, reaching His kingdom. He is the one Teacher, the only Teacher to emulate.

Mrs. Harris continues to be an advocate for education during her retirement from the DeKalb County School System. In short, she is retired from the traditional responsibilities of educating children and working with teachers, but her work moves on in a relentless fashion.

Often when asked of persons who influenced her life in a mentoring relationship, she will quickly attribute much of her success to the loving influences of her parents, along with her sisters and brothers. She will also share, however, that it was her sister, Anna Pearl Scott, whose supportive nature, poise, creativity, flexibility, and perseverance contributed so much to Mrs. Harris's professional accomplishments. "My sister was my confidante," according to Mrs. Harris. Mrs. Harris has tried to carry her sister's many virtues with her personally and professionally over the years.

Education in DeKalb County is an evolving mission. Not many people have witnessed, let alone, shared actively, the many events and images of such great change throughout the years. Fortunately, Mrs. Harris has done just that as she moves from the corridors of the educational arena speaking out on major issues of today and working with schools and their programs to listen to the active and passive voices of our future—the children. Narvie J. Harris will forever be "on the job" working for students.

She continues to be active in Wheat Street Baptist Church youth initiatives and as a trained volunteer assisting those whose lives have come full circle—the elderly, the focus of her energy today. "Perhaps I realize that as we become older, we will become 'the new children' who are a growing population in America today requiring special attention and care," she says of her most current mission.

NARVIE J. HARRIS'S SISTER AND MENTOR, ANNA PEARL JORDAN SCOTT.

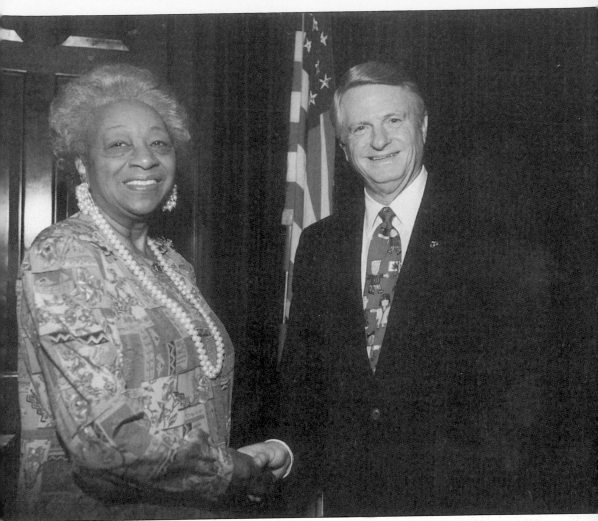

GOVERNOR ZELL MILLER, GOVERNOR 1995. Mrs. Harris accepts the Proclamation for Georgia Retired Teachers' Association (GRTA) Retired Teachers' Month. She has served as president of the organization at the local, regional, and state levels since retiring in 1983.

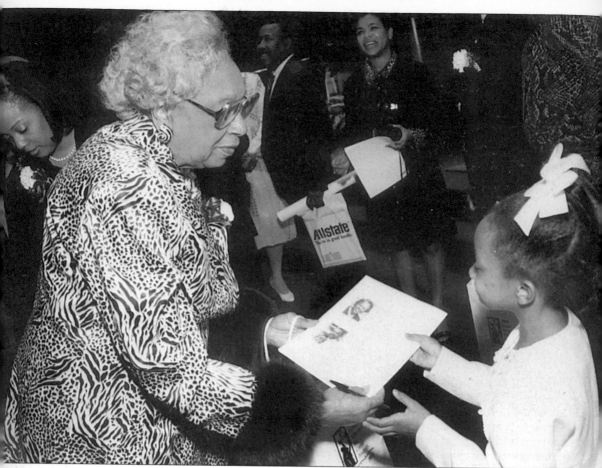

MRS. HARRIS. "Take time to listen to the children. They will tell you what needs to be done on their behalf."

Lesson: Listen . . . Listen . . . Listen. Narvie Harris takes time to listen to the voices of the children. Through their voices, no matter how audible or inaudible, children find ways to let you know what they need, when and in what increments. Our job is first to listen, reach, and teach.

NARVIE J. HARRIS TRADITIONAL THEME SCHOOL (OPENING 1999). Dr. Fannie Tartt, Executive Director, and Dr. Annette Waller, Principal, along with the dedicated school teachers and staff, engaged parents, and achieving students, will carry on the torch lit brilliantly by Mrs. Harris's philosophy of educational excellence for all boys and girls. The expectations set are high and attainable.

DR. FANNIE TARTT
EXECUTIVE DIRECTOR

DR. ARNETTE WALLER
PRINCIPAL

DeKalb School System has had a rich heritage and a glorious past and now faces a great future as it carries the torch with its rewarding legacy into the next millennium.

"Hold high the torch, you did not light its glo;
T'was given up from other hands you know;
T'is only yours to keep burning bright;
Yours to pass on when you no
more need light."

—Anonymous

Honors and Commendations

Awarded life memberships in the Georgia and National PTA Congresses.

Awarded life memberships in the Decatur/DeKalb and Georgia Retired Educators Association.

Awarded life member of DeKalb NAACP.

Awarded the Distinguished Alumni Achievement Award by Clark College (1986) and Atlanta University (1987).

Honored by the planting of trees at Carver High School in Columbus, Georgia, and at C.L. Harper High School for meritorious service in the PTA of Georgia.

Voted Boss of the Year by the Pyramid Chapter of American Business Women Association.

Presented a resolution by Governor Joe Frank Harris commending her as an Outstanding Leader in Education in Georgia.

Recognized as a world traveler having visited every continent in the world, except Australia.

Presented a resolution by The DeKalb County Commissioner for giving of her time, talent, and dedication in educating children and adults in DeKalb County.

Named Honorary Associate Superintendent (a first) by the DeKalb County Board of Education.

Honored in 1998 by the DeKalb Board of Education naming The Narvie J. Harris Traditional Theme School in recognition of her service.

Recognized as one of The Women Who Made DeKalb Great by the DeKalb Historical Society.

Presented a plaque for Dedication and Pioneering in Education in DeKalb 1999 by The Winning Circle of DeKalb Schools.

Presented a Frabel Glass Bird—depicting moving Forward—Looking Back in Education 1999 by Allstate Insurance Company.

Awarded a plaque as Pioneer Worker in Education 1999 by the Million Man March.

Named Outstanding Educator of the Year by the DeKalb County NAACP.

Awarded The Distinguished Service Award for Outstanding Leadership in the Church by The Wheat Street Baptist Church United Sisterhood.

Awarded multiple post graduate scholarships for Atlanta University, Tennessee State University (Nashville, Tennessee), Wayne State University (Detroit, Michigan), Tuskegee Institute (Tuskegee, Alabama), University of Georgia (Athens, Georgia), Georgia State University (Atlanta, Georgia), and Grambling College (Grambling, Louisiana), and other institutions of higher education.

Taught children and held educational leadership positions at all levels (elementary through college).

Presented a Sterling Engraved Tray by the DeKalb County Faculties at a tribute and reception entitled *Through the Years*.

Named Volunteer of the Year in 1998 by the Decatur/DeKalb Retired Teachers.

DEE TAYLOR, CO-AUTHOR.

You have just completed the pages from an era never to be forgotten, as well as the rich gallery of memories shared from the work and reflections of Mrs. Narvie Jordan Harris. What I have experienced through working with her and what you have just witnessed in words and scenes affirm that she is a great sage—that is, a wise and beautiful woman anointed with the gift to teach. As a sage, she has taught many people directly and inadvertently.

I hope that you allowed her wisdom to be delivered through her written word sprinkled with her wit and seasoned with her examples of courage and integrity. She has touched my life as we worked on this project, and I am sure you have been touched by the rare moments she has harbored for such a captive audience who cared enough to read and desired to know what earlier times in DeKalb must have been like.

As a model for teachers and administrators, her example has been "graded" as exemplary. Narvie has taught us how to learn, how to lead, how to follow, how to wait, and how to proact instead of react, how to be fulfilled in one's chosen vocation, and above all, how to give children nothing short of 100 percent. These lessons are not just for educators, but for all persons in the village of raising children.

Because her standards have always reached beyond the highest rubric, those educators who strive to be half the professional she has been will find themselves extraordinary in reaching the lives of teachers and in tapping the potential of children entrusted to them.

DeKalb County School System is far richer today because of the impact that she and those of her era, representative of many other cultures of the 1940s to the 1980s, sacrificed to make education available, equal, and better in the county.

Her account, our new partnership, and my own gratifying tenure in the system make me extremely proud to be a part of her life and DeKalb County.

—Co-author, Dee Taylor, Ed.D.

Dr. Taylor currently serves as the academic achievement coordinator for DeKalb County Schools. Throughout her career, many arenas have recognized her skill and leadership as a teacher, administrator, national educational leader, and consultant. She resides in Stone Mountain, Georgia, where she is the mother of Ryan and Brandon and the wife of Joseph Taylor. She is grateful for the pioneer efforts of Mrs. Harris, who paved the way for her and so many other African-American educators. She is especially endeared to Mrs. Harris for sharing the memories and lessons which enabled them to write this portion of history—"to help us know where African Americans in DeKalb Schools have been so we will know where we must now go."